DIGITAL
PHOTOGRAPHY
MADE EASY

This is a **FLAME TREE** book
First published 2015

Publisher and Creative Director: Nick Wells
Project Editor: Polly Prior
Art Director and Layout Design: Mike Spender
Digital Design and Production: Chris Herbert
Screenshots: Chris Smith
Technical Editor: Nigel Atherton
Proofreader: Dawn Laker
Indexer: Helen Snaith

This edition first published 2015 by
FLAME TREE PUBLISHING
Crabtree Hall, Crabtree Lane
Fulham, London SW6 6TY
United Kingdom

www.flametreepublishing.com

15 17 19 18 16
1 3 5 7 9 10 8 6 4 2

© 2015 Flame Tree Publishing

ISBN 978-1-78361-280-2

A CIP record for this book is available from the British Library upon request.

Printed in China

All non-screenshot pictures are courtesy of Shutterstock and © the following photographers: Zurijeta 3; fotofred 4b & 48; Monika Wisniewska 4t & 14; nito 5b & 122, 124; Pressmaster 5t & 74; Hasloo Group Production Studio 6b & 174; Warren Goldswain 6t & 150; Patryk Kosmider 7b & 220; Semmick Photo 7t & 206; Lou Oates 8r; vadim kozlovsky 8l; Eduard Stelmakh 9b; Showcake 9t; dotshock 10; A.S. Zain 12b; Jessmine 12t; martiapunts 13; lucadp 1 t; Valerio Pardi 16 b; Eduard Radu 17; Jon Le-Bon 18; TungChwung 19; Vladyslav Starozhylov 20; Oleksiy Mark 21, 56; jocic 22b, 62b; Rasulov 23; Robert Kneschke 26; Ffooter 28 b; fototehnik 28t; KULISH VIKTORIIA 30; Szymon Apanowicz 31t; Tatjana Brila 34; Sergey Mironov 37; ExaMedia Photography 38; Ensuper 39; antb 40; Joshua Rainey Photography 41; Eugenio Marongiu 42; Bloomua 43b, 50, 131; Jane Rix 43t; TAGSTOCK1 44; Dirima 45; 1000 Words 46; Twin Design 47 r; Stephan Holm 52; You can more 53; Sashkin 55; vetkit 57, 214l; Canadapanda 58; Coprid 61; Madlen 62t; Sang H. Park 64; Khomulo Anna 66; scyther5 73; Guas 100; Dudarev Mikhail 105; Creative Travel Projects 107; Viorel Sima 109; Marten_House 114; Tompi 117; Ratchapol Yindeesuk 125; Nonnakrit 126; Artem Kovalenco 127; Suslik1983 130; Ivaschenko Roman 132; Niek Goossen 134; Kitch Bain 144b; BONNINSTUDIO 155; Robert Fruehauf 179; Naypong 192 t; OZaiachin 193 t; Paul Broadbent 193 b; EML 194; Masalski Maksim 195; Sergio Stakhnyk 198t; Antonio Gravante 199 b; Nuttapong 199t; maigi 200; fonzales 203b; Andrey_Popov 204; StockPhotosArt 205; John Kasawa 213; urfin 214r; Coprid 215bl; axz700 215br?; jcjgphotography 216bl; LalithHerath 216br; Ruslan Kudrin 216tl & tr; Aleksandr Kurganov 217r; Tony Gates 217l; Joyce Vincent 219; ievgen sosnytskyi 222; FiledIMAGE 224; Sergey Nivens 225; Keith Gentry 226; Jim Parkin 227; Tracy Whiteside 228; kryzhov 232; Jose AS Reyes 233; dezi 236; Rita Kochmarjova 237; Steve Mann 244; Nejron Photo 245.

All product shots are courtesy of and ©: 2014 Adobe Systems Incorporated. 152, 161, 198b; 2014 Apple Inc. 47, 63, 98; Canon (UK) Ltd 2014 1, 192b; 2006–2014 DayMen US, Inc. 215tr?; FUJIFILM 22; Kodak 201t; 2014 LaCie 145; 2014 Lenovo 51; 2014 Microsoft 139; 2014 Nikon Inc. 121; Olympus 2014 31b; 2009–2014 SAMSUNG 144t.

DIGITAL
PHOTOGRAPHY
MADE EASY

CHRIS SMITH &
HANNAH BOUCKLEY, IAN BURLEY,
STEVE CRABB, JAMIE HARRISON, JOËL LACY

GENERAL EDITOR: NIGEL ATHERTON

FLAME TREE
PUBLISHING

CONTENTS

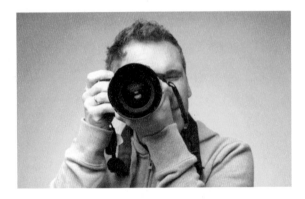

Digital photography and all its associated technology can be baffling, but this chapter will arm you with essential info, including a detailed look at both digital and smartphone cameras, a low-down on lenses and an explanation of the camera's basic functions, such as modes and flash.

Whether you want to edit and print your own photos, download and archive your snaps or share them online, it is useful (although not absolutely necessary) to have access to a computer. In this chapter, we go through the various options available – desktop, laptop, tablet, smartphone – so that you can choose the one that's right for your needs, and we also assess what the best editing software is, both free and paid-for. A quick guide to pixels, resolution, digital colour and file types completes this chapter.

The difference between a good photo and a great photo is minute, as you will learn in this chapter. Most of us just point and shoot, but if you are interested in making every photo you take a great one, this chapter will show you how to do it. Both the technical and aesthetic aspects of great photography are covered, and you will learn pro tips and tricks to turn your everyday snaps into works of art.

Now that you have taken your photos, what do you do with them? Email or share them online, make an album or create a slide show? We show you what the powerful photo software offered by the likes of Apple and Microsoft can do. Learn how to download, open and archive your images and create an easily accessed library, with or without a computer, and get the low-down on how to use cloud storage safely.

EDITING YOUR PHOTOS **150**

Editing your photos is great fun, and can produce fantastic results – don't think of it as a complicated and technical route that should be left to the pros. This chapter will guide you through the wealth of editing options available to you on your computer or mobile device to help you enhance and improve your images.

SHARING YOUR PHOTOS **174**

Sharing your photos used to mean passing prints around, but today, there are endless opportunities for doing so, as this chapter explains. You may choose to email them to far away relatives, but how about sharing them online or viewing them as a slideshow on your mobile device, computer or TV? If you prefer prints, we guide you through the options – DIY or laboratory, and show you how to scan old prints to give them a new lease of life.

CAMERA ACCESSORIES & MAINTENANCE .. 206

Your camera or smartphone may take great pictures, but it is possible to get even better results by investing in some extra kit. Interested? Then this chapter shows you what you need, from lenses, filters and reflectors, tripods and remote shutter-release devices, bags, straps and batteries. And like anything else, they will all benefit from a little TLC now and again – we show you how to keep your equipment in tip-top condition.

SHOOTING PROJECTS 220

Now it is time to put all you have learned into practice. With ideas for inspirational shots, this chapter will encourage you to grab your camera (phone or DSLR) head out and capture some stunning pictures. With advice on both the technical and aesthetic aspects of your shot, our top tips will ensure that you get the best results, whether you're on holiday, at a wedding or simply recording an everyday scene.

INTRODUCTION

The year 1839 was a good one in the history of communication. Two men, Louis Daguerre in France and William Henry Fox Talbot in England, both announced that they had managed to solve a problem that had been vexing scientists for centuries: how to record an image, and make it permanent. Thus photography was born.

DEVELOPMENT OF PHOTOGRAPHY

At the time, it was a crude, slow and highly toxic activity, but as the years went by, pioneers found ways to make it easier: glass plates, pre-coated plates, flexible film. However, by the first decade of the twentieth century, the last big, revolutionary development in photography had already been achieved, with the invention of colour – though it would be decades before it was good enough and accessible enough to really take off.

Left: Early photography required a great deal of skill, patience and time.

Left: All photographs were once printed from gelatin-silver negatives, such as the one here.

DIGITAL REVOLUTION

The first 'digital cameras' were actually video cameras that took still photographs, and the quality was terrible. A few were sold to specialist markets, where the need for instant pictures outweighed concerns about the quality, or the astronomical cost, but they barely showed up on the public radar until the dying days of the twentieth century. Manufacturers kept plugging away, the quality got better, the prices fell lower and lower, until a point came, around 2003, when the general public suddenly realized that here was a viable alternative to their old film cameras which offered not one, but several huge advantages.

Value For Money

Firstly, people could see the pictures they had taken straight away, and that was a revelation. If the picture was no good, it could be re-shot. Suddenly, the nail-biting 'will they/won't they come out?' trip to the photo processors was no longer necessary. If this was the only benefit of digital, it would still be worth having, but there are many more. The removable card on which the pictures are stored can be

Above: Photography in the digital era is far less expensive and wasteful than it was in the days of film photography.

Above: The digital revolution in photography allows you, the photographer, to have control over your image every step of the way.

reused. That means that once you have bought both the camera and a decent-sized memory card, you need never spend money again unless you want to make a print.

Great Results

Digital photography has moved the darkroom to the home computer, smartphone and tablet. This benefit is the one which has had the greatest impact on the hobby of photography, because it gives the user an unparalleled degree of control over the final image. Even relatively inexpensive printers can produce prints that are virtually indistinguishable from silver-based prints.

Above: The beauty of digital photography is its immediacy: share a great shot; delete an inferior one.

IT'S FOR EVERYONE

For anyone who remains unconvinced, the benefits still don't end there. With the invention of the internet, digital photographs can be enjoyed in any number of ways. They can be emailed, seconds after they have been taken, to friends and relatives all over the world. They can be uploaded to any number of social media or photo-sharing sites and sorted into albums, where fellow users can view, rate and comment on them. Or you can build your own image-based website, to your own design.

USING THIS BOOK

Entry into this magical digital world has never been more accessible. High-quality digital cameras have never been cheaper, smartphones are always on hand for snapping those everyday shots and computers have never come loaded with more bells and whistles. But there's a snag: there is a lot to learn. Bytes, megabytes, CCDs, USBs, RGBs, JPEGs, MPEGs ... And that's where we come in. This comprehensive manual covers everything you need to know, from the very basics of composition all the way to image editing.

All You Need To Know

Divided into easily navigable chapters, you can start at the beginning and work your way through, or use it as a handy reference guide and dip in and out of it as required. However you use this book, you will find it an invaluable companion to help you get the very best from what you will soon discover – if you don't already know – is the world's most rewarding hobby.

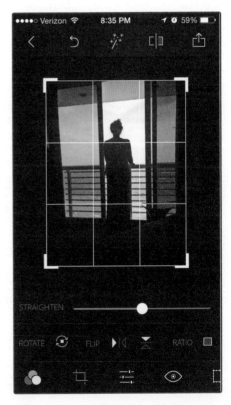

Above: The advent of digital, mobile technology means it is possible to edit your photos on the go..

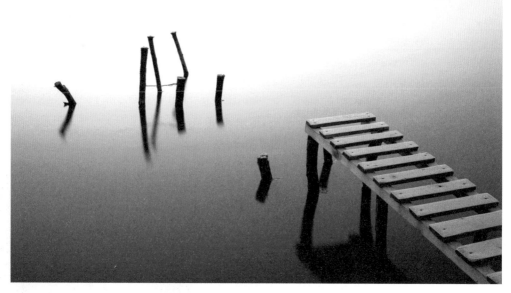

Above: We offer professional advice on how to compose the perfect photo.

Above: All your computer-related queries – downloading, uploading, editing, sharing, archiving – will be explained in this book.

Getting Technical

In order for you to become a great digital photographer, we think that it is a good idea to understand your camera and how it works. Our experts guide you through the anatomy of a digital camera, giving details on the wide variety of functions it has to offer. Smartphones are rapidly becoming the everyday camera of convenience, and so we give the low-down on these devices, with their increasingly impressive lenses and editing capabilities. Although it is possible to do without one, computers (desktops or laptops) have an invaluable part to play and, depending on your particular need, we offer expert advice on the type of computer to go for.

Taking A Great Photo

Digital photography is not only about memory cards and pixels and file sizes, however. Just as important as the technical side is the aesthetic aspect. We have picked out the key factors that we think are vital in taking a great photo, such as composition, colour, light and capturing motion, to help you turn a quick snap into a fantastic image. Our shooting projects are designed to inspire you and help you master a variety of subjects, including landscapes, still life and portraits.

Jargon Busting

Technology is all too often packed with technical terms that can seem like another language to the uninitiated, and digital photography is no exception. Unfortunately, much of it is unavoidable, and understanding the terminology is an essential part of getting more from your camera. We give clear and concise explanations of the more technical aspects of digital photography, such as resolution, compression, digital colour and file type; with a clear understanding of these terms, there is no doubt that you will get more out of your photography.

Above: Learn how to share your snaps with others on sites such as Instagram and Facebook.

Hot Tips

Throughout the book, we've inserted a host of bonus tips from our years of experience using digital cameras. These suggestions and the pro advice offered will help you become a better digital photographer and maximize the potential of your camera, be it a top-of-the-range DSLR or simply the smartphone in your pocket.

CAMERA BASICS

HOW DIGITAL CAMERAS WORK

Digital cameras are complex electronic devices that perform many functions and calculations every time you press the shutter button. Unlike film, the information recorded is not held as a tangible, physical entity, such as a negative. Instead, it records data, a series of binary numbers that a computer can read. So how does this happen?

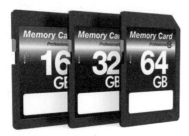

Above: Image files are stored on memory cards in the camera.

BINARY CODE

When you press the shutter button on a digital camera or the touchscreen capture button on a smartphone, several things happen. The shutter opens and the subject is captured on a CMOS or CCD type digital sensor, essentially the digital version of film. This sensor is a small silicon chip holding millions of tiny light-sensitive elements, or pixels. These are arranged in a grid and receive the individual particles of light, called photons, which are turned into an electric charge by the sensor.

At this point, the electric signal is still in an analogue form. These signals are sent to the camera's processor, a small computer chip

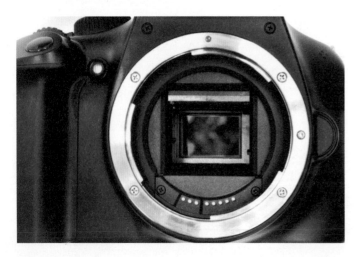

Left: The sensor is the digital version of a roll of film.

that turns the signals into binary code (a series of 1s and 0s), which is then saved in a format that a computer can read. The file that is created is then saved to a memory card, a small, removable storage device in the camera or on a built-in storage drive within the device.

CAMERA JUDGEMENTS

That is the basic science, but much more goes on. As you press the shutter, the lens focuses on the subject, while the sensor measures the amount of light, so that the exposure will be correct. It also measures the colour of the light, so that it is replicated accurately. This process, known as white balance, is added at the processing stage. Other processes are also added to the image, sharpness, contrast correction, etc., using mathematical formulae known as algorithms, designed by the camera's engineers.

Above: A JPEG is an image file.

FILE COMPRESSION

Finally, in order to keep the file size small enough to keep the workflow and memory working efficiently, the file is usually compressed. This involves the camera processor looking for areas of similar colour and detail in the image and throwing some of that information away, thus reducing the file size. This results in a JPEG file, and when the file is opened on a computer, the computer then replaces that information and increases the size of the file again. The JPEG file is then saved on the memory card, and the camera is ready to take the next photograph.

Above: Half-pressing the shutter button gets your shot in focus.

ANATOMY OF A DIGITAL CAMERA

Digital cameras share many of the same functions as traditional cameras, but have other features that you need to become familiar with. Here is a runthrough of the most common features found on a digital camera.

Hot Tip

Be careful not to zoom in too close on a subject. High-resolution pictures can always be cropped afterwards, while maintaining quality.

Above: Digital camera front, showing the mode dial and viewfinder.

Lens

One of the key elements of any camera, film or digital, the lens directs the light from the subject to the sensor. It is used to focus on the subject, ensuring sharpness. Most digital cameras use a zoom lens, which has several focal lengths, and changes the size and perspective of the subject being photographed.

Flash

Photography uses light to record the picture. If there is no light, you cannot take a picture. Most cameras have a built-in flash to add light in the dark, while clip-on accessories can be bought for others.

Hot Tip

The flash can also be used in bright sun to eliminate unwanted shadows.

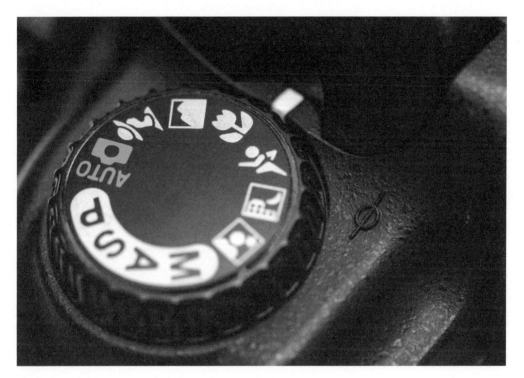

Above: The mode dial allows you to change the way the camera takes the picture.

Mode Dial

Chooses different exposure modes or scene modes, which alter the way the camera takes the picture. You will also usually find a video mode here. Most modern cameras and some smartphones allow you to shoot video at full 1080p high definition.

Navigation Buttons

Usually, there is a cluster of four buttons and a rocker switch or a rotating wheel that navigates through the menu and makes changes. The arrow keys also scroll through the pictures you have already taken when used in review mode. Often, the buttons will have a secondary purpose to operate other features on the camera, such as the flash, self timer and macro mode.

Above: LCDs on cameras and smartphones have become increasingly sophisticated.

Viewfinder

A small lens set into the camera to compose images without using the LCD (Liquid Crystal Display). Many compact cameras now don't have a viewfinder, relying on the LCD monitor instead, just like smartphones.

Zoom Control

Usually a rocker switch or pair of buttons that operate the zoom function of the lens. It is also often used to magnify images displayed in review mode.

Hot Tip

Viewfinders are useful in bright sunlight, when it may be difficult to see the LCD clearly, while also offering more true-to-life colour representation.

TYPES OF DIGITAL CAMERA

Whatever your level of experience or your style of photography, there is a camera out there for you. There are several major categories of digital camera, although a few cross over.

Compact Cameras

Once considered cheap and cheerful alternatives to 'proper' cameras like SLRs, compact cameras have improved to the point where the shooting options and resulting photos come much closer to SLR quality (*see* p. 22). Many higher end compacts have great optical zoom lenses, plenty of control over colour and exposure, a built-in flash and manual focus, among other features. They're attractive to budding and serious photographers due to their often-lower price points and jeans-pocket-friendly size.

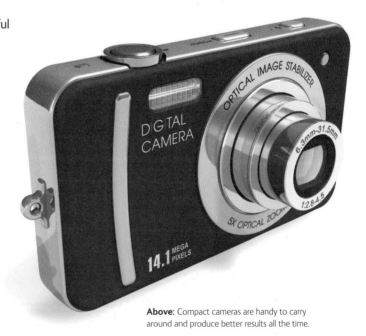

Above: Compact cameras are handy to carry around and produce better results all the time.

Superzoom Cameras

Superzooms are very versatile. They have long zoom lenses and usually a combination of exposure modes to suit everybody from the family snapper to the photographic enthusiast. Superzooms are usually larger than compact cameras, due to the size of the lens, but are still lightweight and small enough to be carried in a camera bag.

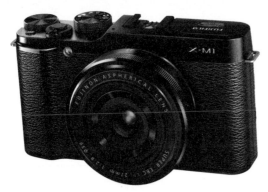

Above: Compact system cameras are becoming more popular.

Hot Tip

A CSC is a great option for photographers who like to be flexible without carting around a hulking SLR.

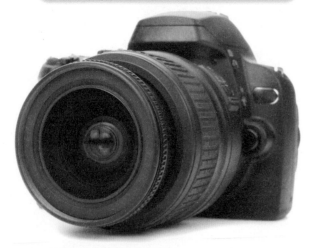

Above: SLR cameras are a great investment if you are serious about photography.

Mirrorless Cameras / Compact System Cameras

A relatively recent but popular addition to the photography world, these cameras promise SLR-quality photographs through large sensors, plentiful shooting options and the ability to interchange lenses, all squeezed into a compact-camera sized chassis. Camera makers are able to achieve this by removing the reflex mirror and optical viewfinder, which you'll read about later in this chapter.

Digital SLRs

The DSLR (Digital Single Lens Reflex) is the most versatile of cameras. Usually aimed at the more competent, enthusiastic photographer, as well as professionals, DSLRs offer high-quality images with lots of control. Different lenses can be used, along with a wide array of accessories. DSLRs are larger than other cameras, and as you build a system with extra lenses and accessories, they can become bulky and heavy to carry around. Among serious photographers the SLR remains the most popular choice.

Smartphones

As smartphone technology has dramatically improved in the last five years, they have become utterly dominant in the digital realm. Their compact size, their ease of use, the on-board editing tools and ease of sharing on the internet and social media, and the fact they're always in our pockets anyway mean many people choose to leave their digital cameras at home. Devices like the iPhone and the top Android phones from Sony, Samsung and HTC are certainly capable compact camera replacements, with their larger sensors, improved lenses, impressive autofocus and the ability to alter elements like exposure and white balance.

Hot Tip

Although smartphone cameras can perform admirably in most situations, do not rely on them for important occasions like weddings.

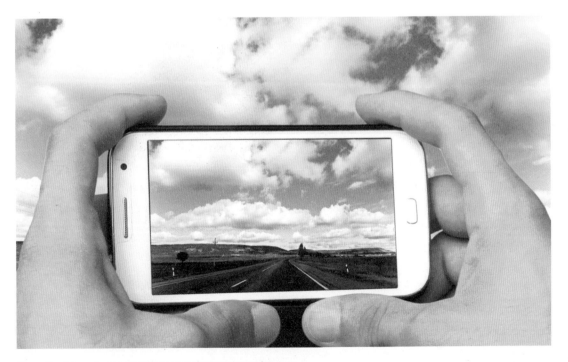

Above: Smartphone cameras are very convenient for spontaneous photos.

RESOLUTION

One of the first considerations when buying a digital camera should be its resolution; the amount of detail the camera can capture via its sensor. Commonly measured in megapixels, resolution has long been a competitive issue amongst camera and smartphone manufacturers. There is an assumption that the more megapixels the better, but this is not always the case.

WHAT IS A PIXEL?

'Pixel' is short for 'picture element', a tiny light sensor that is the basic element of a digital photograph. They make up an image much like individual tiles make up a mosaic. If you put a million of them together you have a megapixel. Each pixel translates to one pixel on a computer or phone screen. Pixels record the colours of an image as red, green and blue, commonly known as RGB. When the colours are all mixed together on a screen, they form a multicoloured image, in the same way as the image on a TV is formed.

Megapixel Requirements

The megapixel number is important when it comes to viewing and printing, as the more detail an image has, the larger and sharper the prints and onscreen image will be.

Below & right: The lower the resolution, the more pixellated your photograph will be.

- **Most compacts and smartphones** now come with pixel counts upwards of 8-megapixels, ranging up to around 20-megapixels. Modern SLRs traditionally come with a pixel count of over 12-megapixels.

- **Cameras offering more megapixels** produce larger-sized files, which take up more space on your memory card and on your computer's hard drive, but which allow you to print larger, crisper photos. For the average user, only around 5–6-megapixels are necessary to produce decent results. If larger prints are needed then, a higher pixel count is necessary.

Hot Tip

Five or six megapixels will produce good results up to A4 on a home printer or from a high-street laboratory.

Quality Over Quantity

Resolution alone is not the whole story, though. The more pixels that camera manufacturers cram on to their sensors, the smaller those pixel sites have to be. A smaller pixel site will gather less light than a larger pixel site given the same exposure. This means that either these chips are less sensitive or that their built-in image processors have to amplify the signal from the pixel site. This also amplifies any non-image-forming noise, which shows as false-coloured pixels in the final image.

Hot Tip

As a general rule, cameras should always be judged by what their pictures are like, and not by how many megapixels they boast.

Above: Larger file sizes will use more space on your memory card and hard drive.

LENSES

The lens is crucial to digital photography, as it is the means by which light enters the camera in order to record the image to the CCD. The lens is also used to focus the image so that it is sharp, and plays a critical role in determining the look of the image, the composition and perspective.

WHAT IS A LENS?

The lens is essentially a series of curved glass elements that are set into a complex mechanism. They move in relation to each other to provide the best focus for any subject at any given distance.

Above: Zoom lenses enable you to focus in on a particular feature.

With very rare exceptions, all digital cameras use autofocus lenses, which automatically detect the subject and lock the focus on to it. Most compact digital cameras and modern smartphones also use zoom-capable lenses, which offer different focal lengths (the distance in millimetres from the centre of the lens to the point of focus) to allow subjects to appear closer and for perspective to change. SLRs accept different lenses, which can be changed as the situation, or personal choice, requires.

Above: A useful accessory, zoom lenses are very versatile.

Different lenses offer different focal lengths, and there are four main types of lenses available for digital SLRs:

1. **Standard**

 Offers a similar field of view to the human eye. Typically, this is the equivalent of a focal length of 50 mm.

2. **Wide-angle**

 Produces a wider-than-normal field of view, allowing more of the scene to be captured in the frame, which makes objects look smaller (and thus further away) than they really are.

Hot Tip

Wide-angle lenses are good for capturing landscapes or buildings, and the increased perspective can be used to add drama.

3. **Telephoto**

 Has a longer focal length and is used to make subjects look bigger (and thus closer) than they are. Short telephoto lenses are good for producing natural

portraits, while longer lenses are good for sport and wildlife photography. Perspective is decreased in telephoto lenses, making the subject look closer to the background.

4. Zoom

Offers a combination of focal lengths and can stretch from wide-angle through standard to telephoto. The advantage of the zoom is that one lens fits all, offering versatility as well as convenience.

Most digital cameras have a smaller image area than traditional film cameras do, i.e. the sensor is smaller than a 35-mm film frame, so smaller focal lengths are needed to achieve the same effect as on 35-mm film. However, because 35 mm has been prevalent for so long, many manufacturers quote 35-mm-equivalent focal lengths as a shorthand for consumers to understand the effect of any given lens.

Above: Wide-angle works well with low angles.

VIEWFINDERS & LCD MONITORS

Before you take a photograph, you need to compose your scene. To do this, you need a viewfinder or a monitor.

OPTICAL VIEWFINDER

The most popular form of image composition has long been the viewfinder. On compact cameras and some mirrorless cameras, the sole means of composing images comes through the LCD monitor. However, a small number of models offer more conventional eye-level shooting with the addition of an optical viewfinder, usually a small lens fitted to a bore-hole through the casing of the camera. The problem with this type of viewfinder is that the image you see is not the same as the image seen by the lens, and some compositional control is lost. In addition, optical viewfinders do not show much shooting or exposure information.

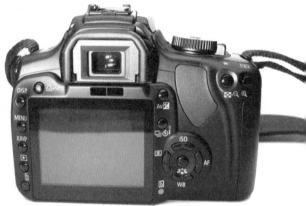

Above: A reflex viewfinder shows the image exactly as the lens sees it.

Hot Tip
Optical viewfinders can also save battery life, as the LCD screen itself can be a drain.

REFLEX VIEWFINDER

With SLRs, the image seen through the viewfinder is exactly the same as that of the lens, thanks to a series of prisms and mirrors. Reflex viewfinders are large and bright and show most shooting information using LED (Light-Emitting Diode, or small light) readouts around the outside, as well

as metering and focusing points within the frame. They don't allow video shooting, however, as the mirror is in the way, and the finder goes black at the time of capture.

LCD MONITOR

Arguably the most important development in digital photography, the LCD has taken the place of optical viewfinders on compact cameras. Like the electronic viewfinder (*see* below), it offers live video feed, and screens can be large, some almost filling the back of the camera. However, LCDs are difficult to see in bright light, and by moving the camera away from the eye to a position where the screen can be seen, camera stability is reduced. This may lead to blurred photos and tilted horizons. Also, monitors can fade over time, leaving photographers with a skewed colour perception.

Electronic Viewfinder

The electronic viewfinder, or EVF, has gained in popularity on superzoom cameras in particular. Like a reflex viewfinder, it shows the image exactly as the lens sees it, (adjusting for zoom and exposure like an LCD), but as a video feed on to a small screen direct from the CCD. Video footage can therefore be recorded and an array of camera data and information can also be superimposed over the viewed image.

Above: A large LCD display can be really useful.

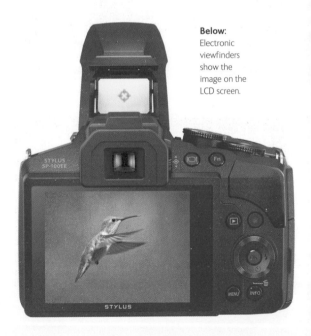

Below: Electronic viewfinders show the image on the LCD screen.

MENU FUNCTIONS

A camera's menu is a vital element that can completely change the way your camera works. It is the means by which you can make changes to exposure, image size and much more. The more sophisticated models have extensive menus with functions you didn't even know you needed.

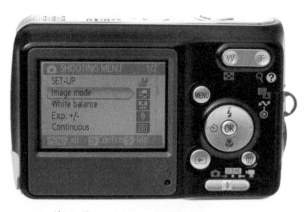

Above: The camera's menu should be easy to navigate.

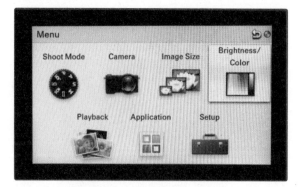

Above: The set-up mode allows you to change the camera's basic settings.

THREE MODES

When you access your camera's menu, a series of lists will appear on the LCD that allow you to set up the camera exactly the way you want. This can be performed for one shot, or saved as your default for all of your pictures.

Most cameras divide the menu into three categories, or modes, with separate, more specific modes within. However, all companies use slightly different menu systems, so use this as a guide rather than a rule:

1. Set-up Mode

This menu should be the first one you access after buying a camera. You can set the camera's date and time, useful so that years later, you can see exactly when a picture was taken. 'Format' completely erases and reformats the memory card,

which reduces the risk of file corruption compared with simply deleting all the previously taken pictures on the card.

2. Picture/Shooting Mode

This allows changes to the way the camera takes pictures, and the sub-menus will change the look of your photographs. Common items include: image quality, to change the resolution or file type of the image; metering, which changes the way your camera measures the light; digital filters, which alter the colour, sharpness and contrast of the images; exposure compensation, to make pictures lighter or darker; and white balance, which can be set to match the exposure to the colour of the light source.

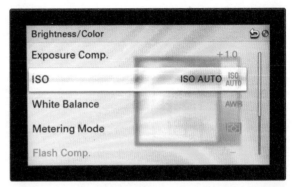

Above: It is easy to alter the ISO speed with a digital camera.

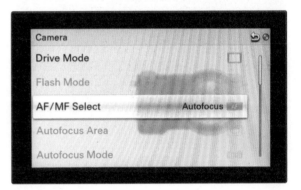

Above: Autofocus can be turned on to make sure images are always in focus.

3. Review Mode

In review mode, you can change the way the camera shows you your pictures. You can usually choose the amount of time that an image is shown on the LCD immediately after a picture is taken. You could choose to display pictures as a slideshow, or a series of small pictures in a grid, called thumbnails. You can also delete pictures you don't want.

Hot Tip

In review mode, you can often tag, or pick, individual pictures as favourites, either so that they can't be deleted or for printing later.

FLASH

Ideal for taking pictures indoors or reducing harsh shadows in bright light, flash is one of the most-used features on any camera. When used properly, flash can vastly improve pictures, but incorrect use can completely spoil them.

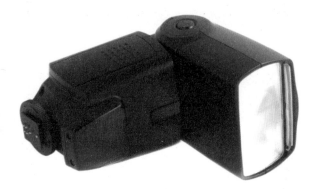

Above: Some cameras require flash accessories, such as a flashgun to be added.

FLASH MODES

There are several different types of flash. Some are built into the camera and sit near the lens, as is most often the case with compact cameras and smartphones, while many DLSR, compact and mirrorless cameras require a flash accessory to be added. When the flash is dedicated to a particular camera, the exposure and flash output are automatically set, but most cameras have a choice of flash modes and it is worthwhile exploring them.

1. **Auto**

 In this mode, the camera will recognize when the flash is needed and automatically turn it on, as well as set the exposure and colour balance. This is ideal for general use, but can result in red eye.

2. **Auto with Red Eye Reduction**

 This works in the same way as the auto mode, but it will also fire a burst of flashes before the picture is taken in order to make the subject's pupils smaller and reduce the effect of red eye. This works reasonably well, but red eye can still occur. It also slows down the operation of the camera, as it can take a second or two for the burst to fire. This can lead

to the subject having their eyes closed (as the preflash triggers a blinking reaction) and less-natural facial expressions.

3. Flash Off

There may be occasions when you don't want the flash on, either for creative reasons (you may want to use the natural light) or because you are shooting candid portraits and don't want to alert the subject to your presence. There are also places, such as art galleries and churches, where flash photography is forbidden.

4. Flash On

This is the manual flash mode – sometimes called fill or forced flash. In this mode, the photographer decides whether to turn the flash on as and when it is needed. This is a useful mode if the sun is behind the subject, or if bright sunlight is causing harsh shadows. Using flash will 'fill-in' those dark areas.

> **Hot Tip**
>
> When the flash is switched off, the camera compensates by setting a slower shutter speed to obtain correct exposure.

Above: You may want to turn the flash on if the sun is behind your subject.

5. Slow Sync

Slow sync, or synchronization, fires the flash whilst using the same shutter speed and aperture as if the flash were not being fired. This is useful at night, when a longer exposure is needed to capture the ambient light, while at the same time, the flash exposure illuminates the subject. Slow sync can also be used to freeze a moving subject while leaving movement trails. Second curtain sync is another version of this, where the flash fires just before the end of the exposure.

Hot Tip

Slow sync makes movement look more natural, with a moving subject being frozen sharply at the front of a movement trail.

Above: Slow sync freezes a subject and leaves movement trails.

MEMORY CARDS

Once you have taken your pictures, they need to be stored somewhere for later printing or copying to your computer hard drive. For this, you need a memory card, often called a media card, and there are several different types.

TYPES OF CARD

When you first buy a camera, you may get a memory card with it, or the camera may come with some memory built in. This is enough to get you started, but will only allow a small number of pictures to be stored, so you will need to buy a decent-capacity memory card as soon as possible (it may work out cheaper if you buy it with the camera).

Most cameras these days take SD (secure digital) cards, while larger cameras use Compact Flash. If you're using a smartphone, your phone will have a hard drive to store photos, but can often be expanded by adding

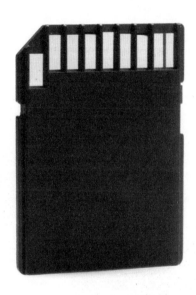

Above: A memory card can hold hundreds of images.

Hot Tip

Large memory cards are especially important if you habitually shoot video on your camera.

a pinky nail-sized Micro SD card. If you're unsure which to buy, consult your instruction book or ask in a camera shop. Always buy the highest-capacity card you can afford, as this saves having to change cards often and possibly losing the full one you just took out.

Secure Digital (SD)

By far the most popular type of card, SD is small and offers high capacity and fast write times. It is also compatible with many other digital devices, such as MP3 players and TVs, while many computers have a slot dedicated to SD. They come in several varieties:

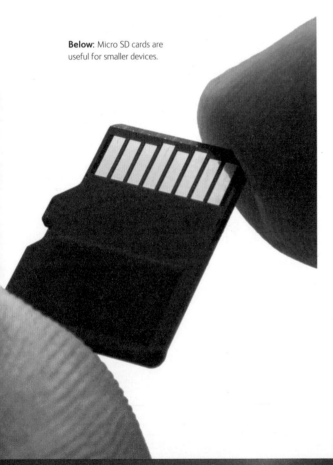

Below: Micro SD cards are useful for smaller devices.

- **SDHC (Secure Digital High Capacity):** offers up to 32 GB capacity.

- **SDXC (Secure Digital eXtended Capacity):** offers 64 GB, 128 GB and beyond. They're the same (physical) size as SDHC cards, but make sure your camera will accept them before buying.

- **Micro SD**: these are used in many mobile phones, and now even some cameras.

Compact Flash (CF)

Once the card format of choice, the larger Compact Flash card is now restricted to use mainly in professional digital SLRs. More recent CF cards use UDMA protocol, which enables the reading and writing of data at much faster speeds than older

cards, making them ideal for the high demands of pro sports photographers and the like. Compact Flash cards are currently available in capacities up to 128 GB.

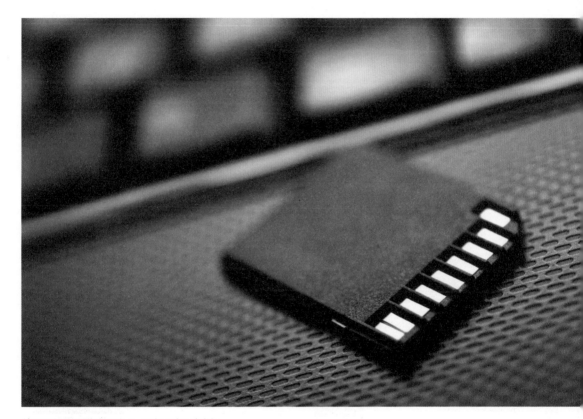

Above: Compact Flash cards are used mostly with SLRs.

Obsolete Cards

Cards like Extreme Digital (xD) were used in Olympus and Fujifilm cameras, while Sony preferred its proprietary Memory Stick (MS) technology. All firms have now dropped them in favour of the industry standard SD cards, which won the format war hands down, but if you're buying older cameras, you may still need these cards.

CAMERA PHONES

Early camera phones had very low resolution and poor control and were almost not worth having. However, things are much different now, with smartphone cameras having evolved to the point where many people now prefer them to a dedicated camera, or at least rely on them to fulfil the role in most circumstances.

EVERYDAY PHOTOS

If you're looking to take DSLR-quality photos, then a smartphone is not the answer, but the everyday photos you may take with a compact camera can often be achieved with your phone, depending on how good the camera is. For many people, mobile phones offer their first

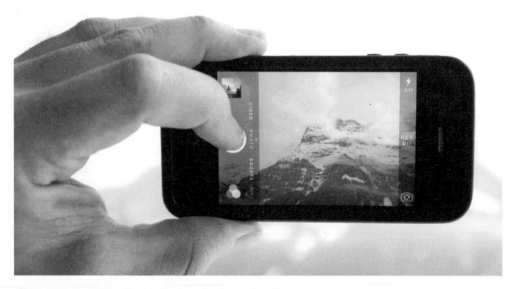

Above: Digital photography options on smartphones have increased rapidly.

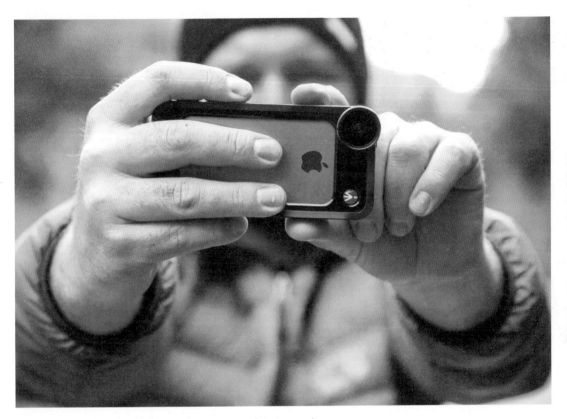

Above: Premium lenses can be added to smartphones to improve their picture quality.

experience of digital photography, and if you compare the specs of the latest camera phones with many low- to mid-range compact cameras it's hard to see what the disadvantage is.

Smartphone Camera Advantages

1. The camera phone is always in your pocket, and ideal for quick snaps.

2. Many phones offer resolution in excess of 12 megapixels (Nokia has a phone with a 42-megapixel sensor), which is comparable to many cameras.

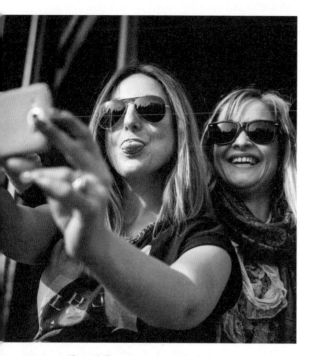

3. Some camera phones have premium lenses from the likes of Carl Zeiss, and now most have one or two LED flash modules right next to the lens.

4. Most phones also have front-facing cameras that are primarily used for video chatting, but can be used to take better-framed self-portraits, or 'selfies' as they're more commonly known.

Above: Selfies are currently completely dominating social media.

Hot Tip

Want to take a quick self portrait? Enlist the front-facing camera. Resolution will be lower, but framing will be more accurate.

Smartphone Camera Disadvantages

1. There is no viewfinder, so you are limited to viewing photos on the touchscreen display (although some companies like Sony are now selling viewfinder accessories).

2. They can be so lightweight, narrow and thin that gaining a steady shot can be difficult, and lenses are often located where you'd naturally be gripping the device.

3. The internal space that can be given over to the camera's circuitry is smaller. As a consequence, although the sensor may have lots of pixels, its physical dimensions are minute compared to a camera sensor. Small sensors have small pixels and small pixels are less efficient at gathering light, resulting in noisy granular images, especially in low light.

4. The flash on camera phones is less effective and can often completely wash out photos or not assist very much. The smaller lens will be prone to distortion, flare and chromatic aberrations that affect image quality, and the only zoom will be digital rather than optical, which further degrades quality.

USEFUL CAMERA PHONE FEATURES

Despite these drawbacks, modern smartphones offer a camera that's always close to hand and capable of taking high-quality photos in a number of situations. That much we know. However, through mobile apps, there are a number of tools available for photo editing, like cropping photos to suit your scene, adjusting colour, brightness, removing red eye and adding various filters to give your photos that vintage feel.

App-tastic

As your smartphone will usually be connected to the internet, these apps also give you the opportunity to share your photos with the world, either through email and messaging or on social networks like Facebook, Twitter and Instagram. You'll be able to upload your

Above: Instagram offers various filters to create the effect you want for your photo.

Above: Sharing photos with friends and family via Twitter, Facebook and Instagram is a great fun.

photos instantly to a cloud storage locker for safe keeping (often automatically as they're taken), while always having your phone on your person means you'll be able to whip out your photos and show them to friends at any moment.

Right: Photos can be downloaded to your computer from your smartphone.

Mobile Magic

Photos can be printed directly from your mobile phone at home or in stores over wireless technology like Bluetooth, while just like a regular digital camera, you can hook your phone up to your computer and transfer over photos for further editing, storing and sharing.

TAKING PICTURES WITH A SMARTPHONE

Every single smartphone now has two cameras, one on the front and one on the back, and they're getting better with each generation of the technology. Taking pictures using a mobile phone is easy, and since there are fewer functions to worry about, there is arguably less to go wrong.

ACCESSING THE CAMERA

Every mobile phone has different controls and the camera is accessed in a slightly different way, so these steps are just a guide rather than a rule:

1. Tap the camera icon on the homescreen to enter straight into the capture mode. (Some phones have a camera icon on the lock screen which you can usually access by sliding the icon up with your finger; this will take you straight to the capture mode without having to unlock your device, saving you vital seconds when you're trying to capture a moving target, perhaps.)

2. Press the shutter button to take a snap: most cameras will allow users to tap an onscreen button to take the photo, while some also have physical shutter buttons on the side of the device.

Above: Taking photos on your phone is quick and simple.

3. On the capture screen you'll also see a menu button, which will control your shooting options, and a video camera icon which will quickly allow you to access the camcorder mode.

Hot Tip

Using an iPhone? The volume rockers on the side of the device also act as a camera shutter button, when the camera mode is enabled.

Below: Tapping the camera icon will take you to the capture mode.

Settings Options

There will probably be an options menu where you can select the shooting mode, focus mode, resolution, flash mode (if you have a flash), self-timer, white balance and other settings. It is always best to select the highest resolution unless you only intend to send the image via an instant message.

Above: You can use your photos in many different apps on your phone.

AFTER TAKING THE PHOTO

Once you have taken a picture, it will be saved to the gallery app and the lens will allow you to take another photo instantly. Tapping the thumbnail of the last shot, which is usually sitting in a corner of the screen, will open up all sorts of options. You can choose to edit it, share it, copy it, print it, set it as wallpaper, assign it to a contact or delete it. Stored photos are held in the photos or gallery section of your phone, from where you can view them as a slideshow. We'll cover this topic more extensively as the book goes on.

Left: You can create albums to keep track of all your photos.

COMPUTER BASICS

YOUR TECH SET UP

The days of 35-mm photography, when photographers processed negatives in a darkroom, or took them to a dedicated lab, have largely passed. Most image manipulation, printing, organizing and storing is now done using a computer, laptop or even a smartphone or tablet.

Above: An iPad can easily be taken everywhere with you.

YOUR DIGITAL DARKROOM

Once you have a digital camera, you need to think about your digital darkroom set-up. The digital darkroom refers to the equipment needed to process and print your photographs. The nerve centre in the darkroom, for most photographers, is a computer – used for transferring, editing, organizing and printing.

Hot Tip

If you are going to share your pictures online, you need to be able to connect your computer to Wi-Fi, but setting up near the router isn't necessary.

COMPUTER

You do not necessarily need a computer to begin digital photography, but your experience will be greatly enhanced if you have one. The important things to look for when buying a computer are memory (RAM) and processing speed; the higher these are the better, as you will be able to work with your photographs more quickly, so buy the fastest computer you can afford. With cameras getting more and more advanced, it will save a great deal of time and frustration.

MAC OR PC?

While Apple Macs were once superior to Windows PCs for imaging applications,. both now offer equal flexibility to transfer, file, store, edit and share your photos; it's just a case of which you prefer.

Hot Tip

Be sure to check out the hard-drive capacity, as the more you have, the more images you can store on the computer.

Above: A good quality flat-screen monitor is best for looking at your photos on.

Above: Windows 8 was launched in 2012 by Microsoft.

Windows PC

Computers running Microsoft's Windows software are by far the most popular in the world. The overwhelming majority of computers made by the likes of HP, Dell, Lenovo, Samsung, etc. run Windows. The latest version of the software is Windows 8, which launched in 2012, although Windows 7 is still very popular.

Mac OS X

Computers made by Apple, such as the iMac, MacBook Pro and MacBook Air, use the Mac OS X operating system. The latest version of Mac OS X is called Yosemite and was launched in October 2014, featuring a brand new Photos app for archiving photos.

Above: Apple computers are renowned for their popularity with creative people.

Above: Mac OS X is made by Apple.

> Hot Tip
>
> If you're about power and portability an Apple MacBook Pro may be the best option.

Laptop Benefits

Many professionals use laptop computers for downloading images on location, because the fold-down screen is easily transported, and modern laptops are super-lightweight and portable. If your main stipulation is convenience, then this is the best option. Computer processors have improved to the point that there is now little disparity between the best laptop and desktop computers.

Below: Laptops are now super-lightweight and convenient to travel with.

COMPUTING NEEDS

The performance and the price of your computer will depend heavily on the specifications of the components within. For example, a computer at the bottom end of the market will struggle when editing large batches of photos and may not have enough storage to save all of your photos. Here are some of the things to consider.

MEMORY

There are two types of computer memory that you need to consider before buying or upgrading: RAM and the hard drive for storage. In both cases, the more the better. But what is the difference and how much should you have?

Above: On a Mac, photos and other images will be stored in your Pictures folder.

RAM

RAM stands for Random Access Memory and is the computer's short-term memory. RAM is used along with the processor to perform the complex mathematical calculations that are at the heart of computer operation. Most modern computers should have at least 4 GB of RAM. Adding more will increase the efficiency of your machine and make it work faster.

- **The speed of RAM**: this depends on the size of the file you are working with, the application you are working in and the action you are performing. The larger the file size, the more likely you are to run out of RAM, and the tasks you perform will take longer, sometimes up to several minutes or even several hours; if the RAM is full, the computer might freeze up altogether.

- **Quit applications**: RAM is used up by other applications you may be accessing at the same time (e.g. the operating system, playing music, browsing the web, downloading files), all of which will slow down your machine. Use memory more efficiently by quitting applications when you are not using them. Graphics and multimedia files such as videos and music use a lot of memory.

The Hard Drive

Every bit of data that you save on your computer is stored on the hard drive, from the operating system and the applications you use to your files, including your pictures. In digital photography, as cameras get more powerful and provide more pixels per picture, the need for more memory to store them is constantly

Above: Your hard drive is where everything you save is stored.

increasing. Large video files, music files and other multimedia files also increase the need for storage space.

○ **How much memory?:** Much like RAM, the more you have, the better. Most new laptops and desktop computers will come with at least 128 GB of storage, while many desktop machines will offer 1 TB (a terabyte is a thousand gigabytes) or more.

Hot Tip

Flattening image files when you are happy with any work you have done will help conserve your computer's working memory

THE CPU

The Central Processing Unit (CPU) is the real thinking part of the computer. This is where the complex mathematical equations that are behind every change to your images are performed. Computers are now available with dual or quad processors that further boost the speed, allowing several complex operations to be performed at the same time. Although many years

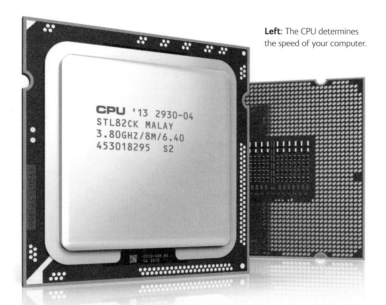

Left: The CPU determines the speed of your computer.

Hot Tip

Clever cooling technologies are devised to keep the running temperatures low, though laptops can often feel hot when running at near-maximum CPU capacity.

ago, it was thought that processor speeds would continue to rise, the reality is that faster speeds are not possible, due to the CPU overheating. Some laptop manufacturers limit the speed of the CPU to reduce heat or power consumption or both.

- **Hot work**: A 3.2 GHz processor working flat out can safely run between 40°C and 60°C, though can rise as high as 80°C or more.

GRAPHICS AND VIDEO CARDS

Along with the processor, RAM and hard drive, digital imaging requires a fast video or graphics card. Some graphics cards can easily be upgraded, while others are built into the computer's motherboard and cannot be upgraded. Like other components, for digital imaging, buy the fastest (i.e. the most expensive) you can afford, otherwise the computer may be performing your image manipulations in the blink of an eye, but it will take 30 seconds for you to see the results onscreen.

Above: A good graphics card is vital, especially for a photographer.

Hot Tip

A slow graphics card can offset the benefits of a fast processor, so buy the fastest you can afford.

MONITOR

Most desktop computers these days will be accompanied by a large, high-definition display added into the package; some are even built into the computer itself, as in Apple's iMac. However, if you wish to supplement your display or use one to plug into your laptop for finer photo edits, the biggest, highest resolution screen you can afford, the better – it is easier on the eye and is invaluable for seeing detail in your images.

Hot Tip

A larger display also allows more space for toolbars when using picture-editing software.

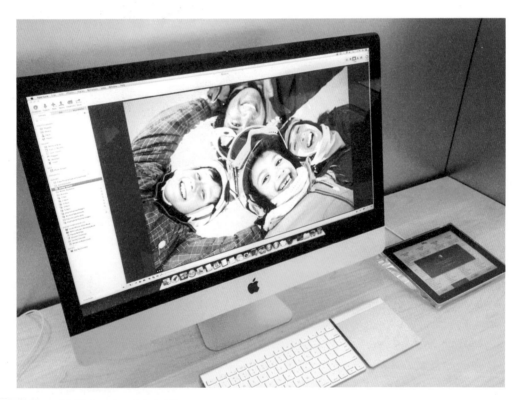

Above: Apple's iMac has a fantastic high-definition screen.

SMARTPHONES AND TABLETS

These days, many people eschew laptop or desktop PCs and choose to rely on their phones and tablets instead, such is their power and influence. Their CPU speeds, processing power and RAM have improved to the point where they can almost rival some computers.

THROW OUT YOUR DESKTOP!

It is very possible to take, store, edit, share and print high-quality photos without going near a traditional computer. Like the computing world, there are two dominant operating systems.

iOS Devices

iOS is the mobile operating system deployed on Apple's iPhone and iPad range. It has a built-in camera mode, which allows users to take up to 8-megapixel photos (including neat panoramas), a Photos app to store and perform simple edits of your pics, as well as a base from which to share photos. Free online-based software called iCloud automatically saves a copy of every photo you take, ensuring that if you lose your phone or tablet, you won't lose your photos.

Right: Apple's phones and tablets use an operating system called iOS.

Android

Android is the extremely popular software made by Google and powers phones from the likes of HTC, Samsung, LG, Motorola and more. Like iOS, it has a camera mode with plenty of shooting options , but they'll vary, depending on the manufacturer. Some Android smartphones pack a resolution of up to 20-megapixels. There's a gallery app from which to edit and share photos too.

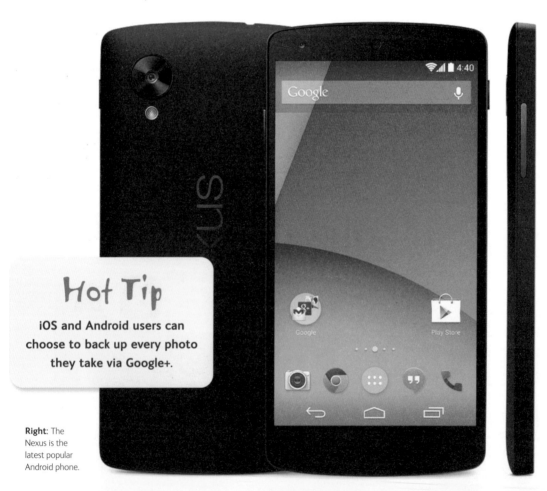

Hot Tip

iOS and Android users can choose to back up every photo they take via Google+.

Right: The Nexus is the latest popular Android phone.

OTHER EQUIPMENT

It is essential to back up your photographs, as the loss of a memory card or damage/theft to a computer can lead to devastating losses. These days, it's easy to back up online through 'cloud' services (*see* page 182), but having copies of your snaps saved to physical media is also worthwhile.

CD/DVD BURNER

You can store thousands of photos using a CD/DVD burner. This is a device that enables you to transfer data, including picture files, to a disk. Many computers still have one built in, but they're becoming less prominent. If you don't have one built in, external burners can be bought relatively cheaply and plugged in via USB. The advantage of burning to discs is, as long as you look after them, they're not subject to hardware failure like an external hard drive.

Left: A CD or DVD burner allows you to save images to the disc.

Saving images to a CD or DVD will also free up space on your computer's hard drive. This is very useful, as the ease of digital photography means that you will quickly build up a huge library of images.

EXTERNAL HARD DRIVE

If you'd rather not have the hassle of multiple discs, then a pocket-sized external hard drive offers capacious storage space for potentially thousands upon thousands of photos and can be plugged into your computer via the USB port.

Left: The external hard drive is a very useful tool for freeing up space on your computer.

PRINTERS

Owning a printer is a lot less necessary than it used to be, with a variety of online and in-store options for printing your photos. However, if you enjoy printing at home, there are still a huge variety of printers available. If you're planning on buying one, think about the size of images you will be making, and whether you want to print images at a larger size than A4.

Right: A printer will allow you quick access to your photos.

Photo Paper

If printing your images at home, it really is worth investing in good-quality photographic paper. Your images will look clearer, sharper and last much longer than on lower-quality paper.

SOFTWARE TO INVEST IN

Depending on your interest in photo-manipulation, you may need to buy some software. Very basic image-editing software will come as part of your computer or will be available as a free download. Tools such as the Photo Gallery app on Windows PCs or the iPhoto app for Apple Mac computers are great free options. These will get you by, allowing you to make rudimentary edits. Some cameras are also bundled with software, but these vary greatly in quality.

Pro Results

For improved editing, Adobe Photoshop Elements for Mac or PC is a good bet. It's only £50/$60 and can be downloaded straight to your computer. Elements will allow you to get by in almost all cases. For professional editing, Adobe Photoshop CC 2014 is probably the most advanced, recognized tool on the market. However, it doesn't come cheap and is available from £105/$120 a year as a subscription.

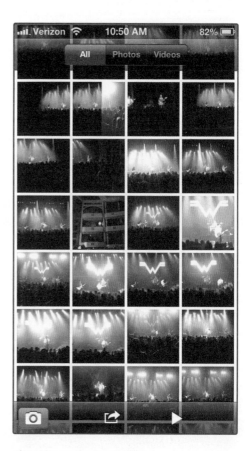

Above: The camera roll on the iPhone will let you look through your photos.

PIXELS & RESOLUTION

Digital photographs are made up of small squares of colour called pixels, and the number of these in an image is the resolution. These pixels translate to your computer monitor. Are you ready for some more technical stuff?

CAMERA RESOLUTION & MONITOR RESOLUTION

Camera resolution is decided by the number of pixels on the sensor. A typical 2-million pixel picture will be made up of 1,600 x 1,200 pixels – in other words, 1,600 pixels across and 1,200 pixels down. If this is then shown on a monitor with a similar resolution at 100-per-cent view, the image will match the display pixel for pixel and fill the entire screen.

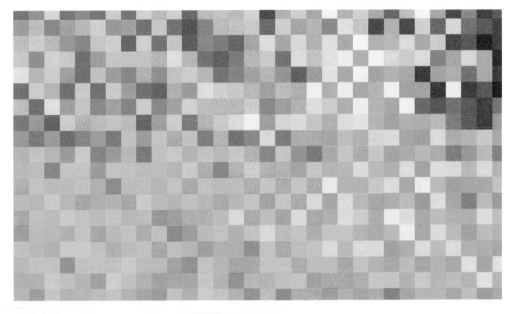

Above: This is a close-up of coloured pixels, the basis of every digital photograph.

A larger resolution image of 4 million pixels (2,304 x 1,712 pixels) will be too big for the screen, so only part of the image will be shown. A confusing addition to the resolution issue is that most computer monitors display images at 72 ppi, or pixels per inch. This further refines the screen size, by indicating exactly how many pixels are in a single inch of the computer screen. Using this knowledge, we can then work out how big an image will appear on-screen. If 72 pixels equal 1 inch, and an image size is 1,600 x 1,200 pixels, then the screen size of the image will be 1,600 divided by 72 and 1,200 divided by 72. Thus the image will be 22.2 in long by 16.7 in wide.

- ○ **The right size**: If you are preparing images for websites or any other screen-based viewing, you must remember to adjust the size accordingly. A 22 x 16 in image will not fit on most computer screens, so the image will need to be altered to a viewing size that will display well on the majority of monitors.

Above: An image at 2 million pixels (top) fills the screen, whereas only part is seen at 4 million pixels.

Hot Tip

It is generally recommended to set your monitor at the highest resolution, to maximize image detail and sharpness.

Right: A photo printer will normally produce good-quality photos.

Hot Tip

Remember pixels per inch (ppi) is for screen resolution, dots per inch (dpi) is for printing.

DPI OR PPI?

Printing images can cause confusion. Rather than pixels, printers use dots of ink, and the print resolution is referred to as dpi, or dots per inch. The simple rule to remember is ppi for screen, dpi for print. The same rule is used for estimating the final print size, but this time, divide the number of pixels by 300, so our 1,600 x 1,200 pixel image becomes a 5 x 4 in print. You divide by 300 because the best results are usually obtained at 300 ppi, although the human eye can rarely see beyond 200 ppi.

DIGITAL COLOUR

Colour is one of the biggest issues in digital imaging. From replicating the colours of a scene with your camera to displaying the colour on a computer monitor and printing your images, colour can be complicated. It is now easier than ever, though, thanks to digital technology.

CAMERA COLOUR

The pixels on a camera sensor are covered by colour filters in a red, green and blue array. Each colour has 256 tonal variations from lightest to darkest, resulting in up to 16.7 million (256 x 256 x 256) colours.

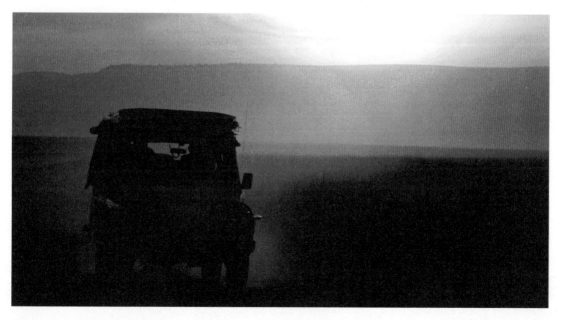

Above: It can be hard to reproduce colours in a printed image.

Most digital cameras do not accurately reflect real-world colours. Research shows that consumers prefer more vivid colours in their images, with more saturation. This is partly due to memory – we remember colours more vividly than they really are – and also because we prefer to see deep blue skies, healthy skin and bright, bold colours, which may not be a true representation of reality. Cameras have been developed to cater for this.

COLOUR PROFILES

Colour profiles are standards that allow different devices to match a particular colour. Each colour in a single pixel is recorded as binary data, described by a string of up to 24 numbers. Every device that uses that image, be it a

Left: The technology needed to reproduce colour accurately is improving all the time.

camera, PC or printer, needs to be able to understand those numbers and replicate the colours accurately. So a standard colour space (the extent and limit of the colours that can be represented) is used that all devices understand. There are two common colour spaces used in digital imaging.

sRGB

sRGB is the most common and simple profile to use, and most compact cameras will only offer this option. It can reproduce most colours, but by no means all that are displayed on a monitor. Use sRGB for images that will be viewed unedited. While using a restricted colour space may seem like throwing a lot of useful data away, printers cannot always display those colours captured and manipulated in other colour spaces. In effect, sRGB saves you from throwing away data at a later stage.

AdobeRGB

This is a second option, offering more sophisticated digital colours. It has a wider range of colours than sRGB, which means a broader range of colours can be recorded, and also gives more scope when you are manipulating the exposure and colour of an image. Professional printers use AdobeRGB, and it is the preferred choice for images that need to be retouched on a computer.

Hot Tip

Be prepared that printed inks may not replicate the brighter colours of a monitor.

COLOUR MATCHING

Printed pictures can often look very different from what is seen on a monitor. This is due to the different nature of the two mediums. Monitors output in transmissive light – the light comes from behind the image, into the eye. Images therefore tend to look brighter and more colourful. Prints are viewed via reflective light – the light is bounced from the print to the eye, so they look darker unless you view them under a very bright light.

FILE FORMATS

Cameras take images in a number of file formats. For a compact camera, this may be the commonly used JPEG, while for more sophisticated cameras other formats such as RAW and TIFF are options.

image.JPG
2,048 x 1,536

JPEG

By far the most common and popular format, JPEGs are processed images that are compressed into smaller saved files. When opened, the file returns to its original size. Because of their small size JPEGs, can be stored quickly, meaning that your camera is faster to operate, and more images can be stored on your memory card and hard drive. However, the compression system can sometimes cause defects in your images. Compression means using less storage space, which means less image data. Consequently, JPEG is known as a 'lossy' format as it throws away some of the image information.

- **File size:** Image files are either stored as compressed or uncompressed. JPEGs are compressed files that are smaller when stored than they are when opened. For example, a 3-megapixel camera will produce a maximum file size of 9 megabytes (MB) of binary data. This means that when you open your picture on the computer, it uses 9 MB of memory. If you look at the size of the unopened file in your pictures folder though, it will probably be about 1 MB. That is because the file is compressed. An uncompressed file will show a file size of 9 MB both when opened and when closed.

- **Compression Ratios:** Most cameras offer a choice of three compression ratios. On a digital camera this is often found in the Quality subheading in the main menu. Often this will be depicted as a set of stars, or by high, medium and low options. Whenever possible chose the highest quality. The lower the quality, the more your picture will be compressed, with more data discarded. This means that you can fit more pictures on your memory card, but the likelihood of picture-spoiling problems increases.

○ **Compression**: The nature of the scene in an image to be compressed will also have a bearing on the amount of compression that can be applied. Images with lots of fine detail will not compress as well as more simple shots do.

RAW

The RAW file is essentially a digital negative, the data that comes immediately from the camera, bypassing the camera's processor and retaining all the original information. Many photographers prefer to add these processing changes themselves for maximum artistic or technical effect.

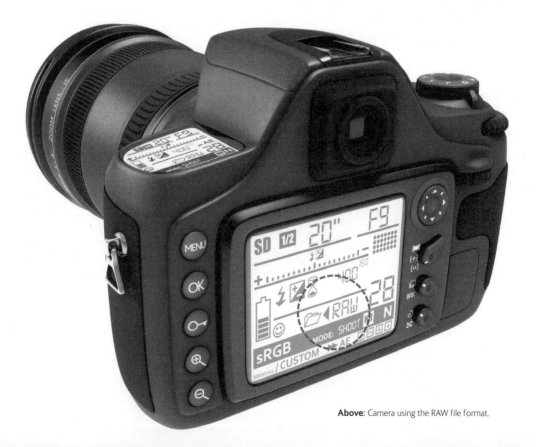

Above: Camera using the RAW file format.

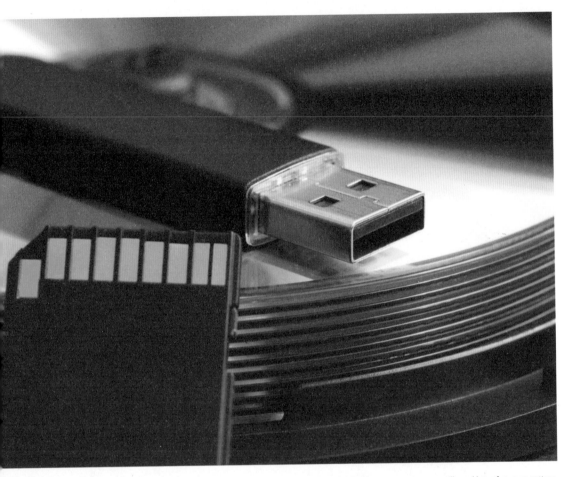

Above: If you have a large number of TIFF files on your camera you'll need lots of storage options.

image.tiff
441 x 229

TIFF

Once the most popular format, a TIFF file is processed by the camera but not usually compressed, often resulting in very large files. This makes the camera slow to work with because of the amount of data that needs to be processed, and memory will be limited. TIFF is a popular format in which to save images on a computer, however,

particularly if you choose the uncompressed option. This means that all the data left by the software is present and the image quality will not be reduced. However, the large file size does mean that fewer images can be stored on your hard drive or CD.

DNG

DNG is a fairly new format developed by Adobe, to overcome the archival problems of RAW files and the danger that files from older cameras will be unsupported by future software packages. The DNG file is converted from the original file with no loss of information, but Adobe has promised to continue supporting the file type indefinitely.

PSD

If you use Photoshop and make adjustments to the images using layers or other means, you should save any work in progress as a PSD. This saves the state of the file and layers, allowing you to go back to the image and make corrections and changes without destroying the original image.

Hot Tip

RAW files vary between different makes and models of camera, and special software is needed to open and use the files before saving.

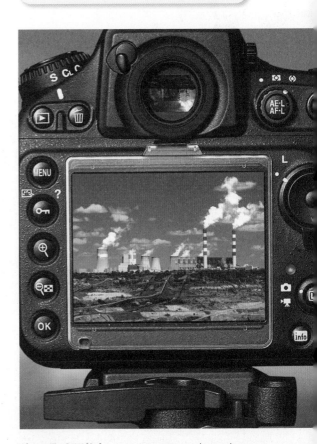

Above: The RAW file format gives accurate control over colour.

TAKING GREAT PHOTOS

THE AESTHETICS OF PHOTOGRAPHY

To be a good photographer, it is necessary to master both the aesthetic and technical aspects of the medium. The aesthetic part is about whether or not the picture is pleasing to the eye – and this is determined by several factors: the light, the choice of subject, the expression (if it is a portrait) and the composition.

Above: Unusual architecture can make great photos.

CHOOSING THE COMPOSITION

Good composition involves thinking for a moment before pressing the shutter, taking a quick look around the frame and deciding if the picture can be improved by zooming in or out a bit more, by moving the camera slightly up, down or to the side, by finding a higher or lower viewpoint, by moving closer or further away, or by tilting the camera, perhaps to the vertical format. You make these decisions every time you take a picture, even if only at a subconscious level, but paying more attention to these processes will result in much better composition.

CHOOSING THE LIGHTING

The other main factor influencing a picture's aesthetics is the lighting. How is the light falling on the subject – hard and shadowy, or soft and diffused? Is it a warm or cool light? From which direction is it coming – from the front, side,

above or behind? If you are photographing in natural light you cannot easily change its position but you can change your position in relation to it. By moving round to the other side of a building you can shoot the sunny side or shady side; by asking a person to turn around you can get the sun behind them instead of shining in their eyes.

Hot Tip

By coming back to the same spot at a different time of day, you will get a completely different type of light altogether.

TECHNICAL POINTS

The technical aspect of photography involves setting the lens, aperture, shutter, and the various digital functions, such as resolution, compression and ISO sensitivity (the International Standards Organization setting that adjusts how sensitive the camera is to light), to obtain a good result. Modern digital cameras can control all of these technical features automatically, but these also all have a bearing on the aesthetics of the image, so if you leave all these decisions to the camera, you are not completely in control over the final image. An understanding of these technical aspects can be used to create visually pleasing images, rather than just records of events.

Above: Symmetry in your subject will make for an interesting picture.

COMPOSITION: RULE OF THIRDS/SYMMETRY

Since the days of Ancient Greece, artists, architects and great thinkers have pondered what makes a building or a picture visually pleasing, and have attempted to explain it with the use of mathematical and geometric principles. These principles can determine the ideal shape of a painting, and where the important elements should be positioned on the canvas for the most harmonious effect.

IMAGE PROPORTION

Although it may seem odd to apply mathematical rules to art, there is some validity to it, which is why great artists, from Leonardo da Vinci to Salvador Dalí, have followed them to some extent. Even the image proportions used by most cameras today are based on the classic compositional ratios of 5:4 and 3:2. Picture frame sizes follow these ratios too.

Above: Balance your composition with different elements.

WHAT IS THE RULE OF THIRDS?

Imagine dividing your picture area into a grid of two horizontal lines and two vertical ones, all the same distance apart – like a noughts and crosses grid. Each line will be one third of the way in from either the top, bottom, left or right side. The Rule of Thirds says that you should place important elements of your

scene on those lines. The real 'hot spots' are the four points where those lines intersect.

When photographing a person, you should put them one third of the way in from one side rather than in the middle of the frame. With a landscape, that big tree or windmill should also be on one of the thirds, and the horizon should be placed on the upper or lower third. You always want to take the eye through the image, and when the subject is placed in the centre of the image, your eyes don't know which half to look at!

Above: The subject of a photo often looks better a third of the way in.

Think Outside the Box

This rule works surprisingly often, but if used repeatedly and relentlessly, a set of pictures will eventually begin to look repetitive and boring. It is also the case that, while the Rule of Thirds creates a sense of harmony in your pictures, you may not always seek to convey harmony.

- **Break the rules:** Create a sense of drama and discord in your picture by placing a subject right in the middle of the frame. When combined with a wide-angle lens, for example, this can produce a great in-your-face effect.

Hot Tip

On many digital cameras, smartphones and tablets, you have the option of turning grid lines on to help with photo composition.

COMPOSITION: GEOMETRY (LINES, SHAPES & PATTERNS)

The eye is an undisciplined organ. Without guidance, it will wander all over the place, never entirely deciding what to settle on. With modern computer technology, it is possible to track the movement of the eye and plot its course as a line.

GUIDING THE VIEWER

It is possible, and desirable, to use elements within your scene to guide and corral your viewer's eyes in a specific direction. In Western culture, where books are read from left to right, the human eye instinctively enters a picture from the left and travels across it. It would be wonderful if you could compose your shot to provide a long path, road, fence or wall running across the picture from left to right, with an interesting landmark or geographical feature at the end of it, so that the viewer's eye can follow the line through the picture and get a visual reward at the end. The human eye likes to be guided like this, and told what to look at.

Left: Use the subject to guide the viewer's eyes in a specific direction.

MAKING USE OF LINES

Learn to look at your subject not as what it actually is, but as a series of shapes and lines. In your head, mentally draw it – a long, straight line here, a big curve there, a wavy line over there – and by changing your position or zooming in or out, use those lines to guide the viewer around the image. Diagonal lines create drama, and those coming from the bottom left lead the eye into a shot. Try not to let the eye wander out the other side of the picture without resting on anything.

MAKING USE OF PATTERNS

Repeating lines and shapes is good too. They create a natural pattern or grid, which conveys a sense of order. We are not often aware of patterns in everyday life, but if we look for them, we find that they are everywhere; in the repeated windows on the side of an office building, the rows of apples on a market stall, the pebbles on a beach, the shadows cast by railings on the pavement – the

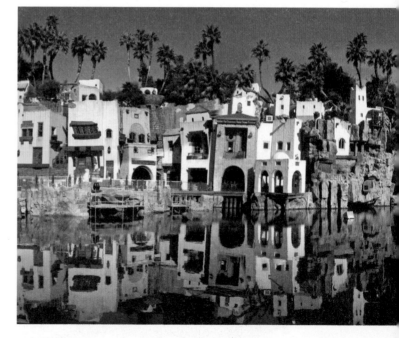

Above: Reflections are useful in helping to create a sense of symmetry.

COMPOSITION: NATURAL FRAMES

One reason why we put pictures into frames is that the frame separates the art from its surroundings and forms a boundary that helps keep the eye within the picture. It is another eye-corralling tactic.

FINDING NATURAL FRAMES

For centuries, artists and photographers have found natural elements within their scene to provide a ready-made frame for their subject and help to prevent the eye from wandering out of the picture and losing interest. It is yet another device for holding the viewer's attention, and for creating harmony within the image. These are some of the classic devices used by photographers:

Doorways, Windows & Archways

Shoot through open doorways so that the doorframe becomes a natural frame for whatever is visible though the door. Windows and archways, such as in a church or ruined castle, can be used to the same effect.

Left: Frames create harmony within the image.

Trees

Photograph a landscape from under a tree, so that the overhanging branches droop down into the top of the frame from above. This gives the viewer a sense that they are peeking out into the landscape but, crucially, the branches help to prevent the eye from wandering out of the top of the frame. Placing the trunk of the tree down the left- or right-hand edge creates a frame to the side. Shooting through the boughs of a tree can create a v-shape frame for a landmark in the middle distance.

Other Frames

When you are out with your camera, look for interesting and unusual ways to frame your picture, such as shooting through a car window, or using people as a frame.

FRAMING PEOPLE

Frames can also be used in portraiture. A bob haircut is among many hairstyles that provide a natural frame for the face – use things like this to your advantage. If the model is confident, try placing their hands and arms in such a way that they frame the face, either in a self-consciously stylized way or, if the subject is less used to posing, in a more subtle and natural position which, nevertheless, still forms a frame.

Above: Natural frames are all around us.

Hot Tip

For a more interesting shot, try shooting through a crowd, or through the 'window' created by a hand on a hip.

COMPOSITION: VIEWPOINT

More than 90 per cent of photographs are taken from between 1.5–1.8 meters (5–6 feet) above the ground. This is the height of the average adult's eyes. Very few people think to stoop down low or find a higher vantage point, and yet those who do are often rewarded with more visually striking and unusual results.

Above: Great detail can be captured from high up.

SHOOTING FROM HEIGHTS

The most obvious reason for seeking a high viewpoint is to get a better view – perhaps to see over a crowd. While this is a valid reason, and is a much better strategy, on the whole, than trying to shoot through the crowd, it is not always necessary.

High viewpoints provide a better view of distant landscapes, and let you see more detail in the middle distance. In the city, head for the top of a tall building to get a sweeping, uninterrupted vista of the metropolis, or find an open window halfway up to photograph an adjacent tall building (such as a church) without having to tilt the camera upwards (which makes the sides appear to converge as if the building is falling over).

○ **Kids'-eye view:** Taking a high viewpoint to photograph children or animals is not generally recommended as standard practice, but does serve to emphasize their smallness and can add humour if used sparingly.

SHOOTING FROM LOW DOWN

There are times when it is better to bend the knees and shoot from a low viewpoint. In general, you'll get better results photographing children if you crouch down to their level and look them in the eye, as if you are entering their world. The same applies to pets. Getting down low means you won't get a distorted view of them (such views can give your subjects a disproportionately large head) and is much more flattering.

SUBJECTS AT GROUND LEVEL

Landscapes can be shot from ground level to emphasize the foreground. You may wish to draw attention to some flowers, or show the texture of sand, stone or cracked earth receding into the distance, or perhaps you want to use a line such as a path or road marking to pull the viewer in from the foreground to the horizon.

Above: Remembering to look up can result in fantastic, unusual images.

- **Use the right lens:** If you want that emphasized foreground to be sharp, it is best to use a wide-angle lens. To get a blurred foreground, you will get better results using a longer focal-length lens.

Hot Tip

Many digital cameras offer an LCD screen that can tilt and swivel, making high- and low-level photography much easier.

COMPOSITION: SHAPE & ORIENTATION

Just as few people think to select a higher or lower viewpoint before taking a picture, most amateur photographers keep the camera in the horizontal position for all their pictures, irrespective of the shape of the subject, and they do not think to rotate the camera 90 degrees to see if that improves the composition.

GETTING THE ORIENTATION RIGHT

There is some confusing terminology in photography, whereby a horizontally oriented image is known as 'landscape format' and a vertically oriented image is called 'portrait format' – irrespective of the subject. This terminology applies to both the camera position and the orientation of prints, but the terms are misleading.

No Right Way

Firstly, there is no rule that landscapes should be taken horizontally and portraits vertically. Indeed, there are thousands of examples of great vertical landscapes and horizontal portraits. Do take a good look at your subject before shooting, to see whether or not the shot would look better if you turned the camera. Many professional photographers shoot their subjects both ways, as it gives the client more options in designing the layout of the page on which the photograph will be used.

Square Format

Sometimes, you may, for aesthetic reasons, eschew both orientations and go for a square image. Many professional medium-format cameras produce square images straight out of the camera, and photographers such as David Bailey are known for their square portraits of personalities such as the Kray twins. Consumer cameras tend not to produce square images,

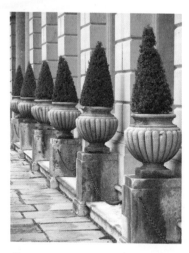 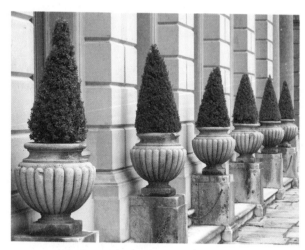

Above: Portrait images can offer a new perspective, while landscape images are a popular option.

but photographs can be cropped, if the subject looks best that way, and square picture frames are widely available.

Panorama Format

If the square format doesn't appeal, try going to the other extreme and create a long, narrow, letterbox-shaped image – either in the horizontal or vertical orientation. This type of image, known as a panorama, is achieved either by cropping the top and/or bottom (or sides) off a normal picture, or by shooting two or more pictures of adjoining parts of the scene and then 'stitching' them together to form a seamless whole.

> ### Hot Tip
> Square, Polaroid-style aspect ratios are coming back into fashion, thanks to photo-sharing mobile apps like Instagram.

IMPORTANCE OF THE SUBJECT

In conclusion, no one is forcing you to stick with a set-ratio, horizontally shaped picture if it does not suit the subject. Don't be afraid to turn the camera or change the shape of the image altogether later on.

COMPOSITION: WIDE-ANGLE PERSPECTIVE

The standard lens on a digital camera is so called because the view of the world that it produces is roughly equivalent to that seen by the human eye. In other words a subject at a given distance appears to be roughly the same relative size and distance away as it does when you look at it with the naked eye.

Above: A wide-angle shot makes a striking photograph.

LIMITATIONS OF A REGULAR LENS

This is fine for some things, but sometimes you can't bring everything into the shot and you can't stand back far enough. This is a particular problem with big groups and small interiors. Conversely, sometimes you just can't get close enough to your subject, either because you are at a sports venue such as a Grand Prix or football match, or because your subject is shy or dangerous, as with much wildlife.

Lens Options

Luckily, by changing the arrangement of lens elements within the lens, optical scientists have created wide-angle lenses (which make things look further away) and telephotos (which appear to bring them closer), and most cameras nowadays come with a zoom lens that is slightly

wide-angle at one end and telephoto at the other. These lenses, by dint of where they make you stand, produce an optical side effect that can be put to good compositional effect.

USING A WIDE-ANGLE LENS

Shooting from close up with a wide-angle lens creates the illusion of exaggerated perspective, so that subjects up close to the camera appear much larger than those further away. By being close to a foreground area, you can give this much greater prominence in the image. This works very well with low angles. Want to add a strong leading line cutting diagonally through the image? Use a wide-angle and get closer to it to make it really jump out at you.

Use Sparingly

Photojournalists often favour wide-angles for the sense of drama they can give to a scene. The wider the angle of the lens (i.e. the shorter its focal length in mm), the more exaggerated the effect. However, if a lens has too wide an angle, the field of view begins to distort. Straight lines begin to turn into curves until, at their logical conclusion, wide-angles become fisheye and everything (including the shape of the image itself) becomes circular. These lenses can be good fun, but should be used sparingly – their useful applications are quite limited.

Hot Tip

Use a wide-angle lens and get close to a portrait subject or candid street scene. It provides a sense of immediacy to the viewer.

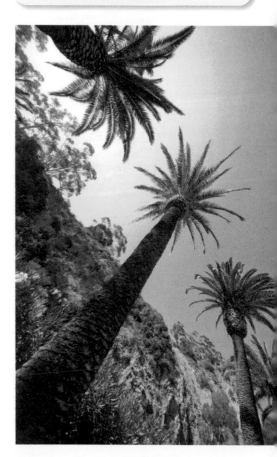

Above: Wide-angle works well with low angles.

COMPOSITION: TELEPHOTO PERSPECTIVE

Telephotos have the opposite effect to wide-angles. When used from afar, they compress perspective, making objects which in reality are far apart appear to be almost on top of one another. Distant hills or other elements in a landscape are apparently 'brought closer' and made more prominent in the image.

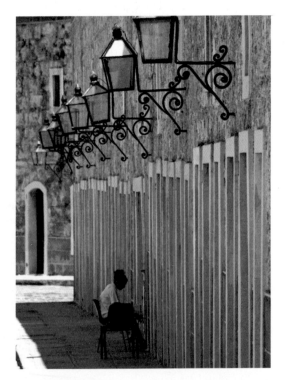

Above: By using a telephoto lens, natural patterns can appear emphasized.

TRICKS OF THE TELEPHOTO LENS

Cars on a racetrack seem inches apart when viewed head on (not side by side). when in reality they may be some distance apart. The telephoto trick is used in movies to good effect. In a scene where someone may be running down a railway track towards the camera, with a train coming up behind them, the use of a long telephoto lens will imply that the person is about to be run over, when in reality there may be more than 50 metres (164 feet) between them.

Telephoto Effects

With telephoto lenses, perspective is flattened and appears more two dimensional, which also helps to emphasize natural patterns and tonal contrasts within a scene. Portraits and street scenes take on a different tone. Far from getting a sense of being in

the middle of the scene, as the viewer is made to feel with wide-angle lenses, the viewer now becomes a voyeur, distant and more detached from the emotion of the moment. This is not necessarily a bad thing. It all depends on what you are trying to convey.

Drawbacks

One side effect of telephotos is their reduced depth of field. The zone of sharp focus seems narrower, so your focusing needs to be more precise with a telephoto than with wide-angles. With telephotos, you cannot get away with manually setting the lens to a point such as 2 m (6 ½ ft), stopping the lens down to f/8 and leaving it there, in the knowledge that everything in the frame will be in focus. However, the narrow focus effect of telephotos can be helpful, especially with portraits, because it makes it easier to throw any distracting background detail out of focus and really concentrate the attention on the face of your subject.

Above: Telephoto lenses can emphasize natural patterns.

COMPOSITION: USE OF COLOUR

So far we have concentrated on using shapes, lines and perspective as composition aids, but one image component that has a huge impact on the viewer is colour.

COLOUR PALETTE COMPOSITION

It is the photographer's job to make sense of colours and, by careful use of composition, create something interesting out of them. They are essays in colour. Therefore it is worth taking time to

Above: Vivid colours result in striking images.

understand how colour applies to photography. The colour palette is divided into three primary colours: red, green and blue (the primary colours in light are different from those we are familiar with for paint). By varying the proportions of these three colours, every other colour in the spectrum can be produced. Most digital camera sensors are composed entirely of blocks of red-, green- and blue-filtered pixels.

Complementary Colours

Each primary colour has a secondary or complementary colour, made up by combining the other two primaries. The complementary of red, therefore, is cyan (a type of turquoise) as it's made up of green and blue. Green's complementary colour is magenta (bright pink) made from red and blue, and blue's complement is yellow (a mixture of red and green light).

○ **Mix it up**: Images that cleverly use a primary colour with its secondary colour often look good. But don't over-use this concept. Scenes that contain all the primaries may clash, but there will be occasions where they look good together – such as in a stained-glass window.

ISOLATING COLOURS

One technique that often works well is to isolate a single colour, such as red or yellow, so that this is the only strong colour in the scene. Think of a frame-filling detail from a red London bus, or perhaps a field of vivid yellow rapeseed, which looks good not only against a blue sky (its complementary colour) but with the sky cropped out, and perhaps a lone figure walking through it. Landscapes are often essays in different shades of green.

THE COLOUR OF LIGHT

One final point to consider is the colour of light. An object can appear to change colour according to the hue of the light falling upon it. A banana will not look yellow if it is lit entirely by red light. Brightly coloured lights are extremely photogenic – think of dusk and night photos of cities, with their neon and other multi-coloured lights.

Above: Colour combines with pattern to great effect.

COMPOSITION:
SEEING IN BLACK & WHITE

Once upon a time, all photography was black and white. Early films could only record the intensity of light, not its colour. Colour photography was invented early in the twentieth century, but it took another 50 years for colour to be good enough and cheap enough to gain mass popularity.

Below: Black and white is ideal for capturing textures.

THE PERSISTENCE OF BLACK & WHITE

Digital has been colour from the outset, but despite all the advances in colour technology, black and white photography will not go away. There is something special about black and white photography – also known as 'monochrome', 'mono' or just plain 'b&w'. It has the ability to get to the heart and soul of a subject without the distraction of colour. It isn't superior to colour, but neither is it inferior. Whether you choose colour or black and white depends on what suits the subject and what you are trying to say.

Hot Tip

Although you can shoot in colour and convert your pictures to mono later, you may wish to set the camera to its black and white mode.

VISUALIZING BLACK & WHITE SCENES

To achieve successful black and white images, you must first learn to see the world in a different way. You need to visualize a scene without its colour in order to assess how it may look as a black and white print. For example, scenes that rely on colour for their impact, such as a carnival or fairground, are unlikely to succeed in mono.

- **Similar tones**: Some colours that look different in the real world may reproduce as the same tone in black and white. For example, the three primary colours (red, green and blue) may all reproduce in black and white as the same shade of grey.

SUBJECTS FOR BLACK & WHITE

Subjects that work best in mono are those that explore shapes, tones and textures, and the interplay of light and shadow. Portraiture also works very well in mono, and can be more flattering than colour, because blotchy skin, spots and ruddy cheeks can be made less obvious or even made to disappear.

- **No need for filters**: Black and white film users have traditionally used colour filters over the lens to control the relative tones of the colours on the film. For example, a red or orange filter darkens a blue sky. This is unnecessary in digital, because the individual colour channels can be independently adjusted later, on a computer.

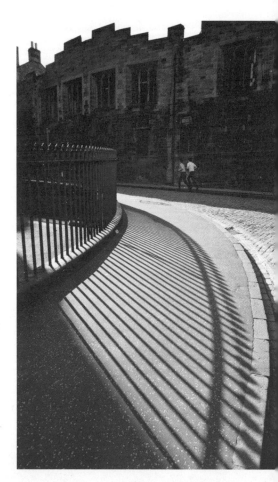

Above: Patterns, light and shadow work together here.

FOCUSING: MODES

Probably the worst technical mistake you can make is for your picture to be out of focus – which is why modern digital cameras and smartphones are stacked with technology to help to ensure that this doesn't happen. Most of the time it works, but occasionally it doesn't. With a little knowledge, the failure rate can be reduced to almost zero.

AUTOMATIC FOCUSING

These days, we take automatic focusing (AF) for granted, but the technology is quite recent. The first autofocusing camera didn't arrive until 1977! There are two types of AF.

Active AF

This is used by simple cameras, in which an infrared beam is fired at the subject to measure the distance and then the camera sets the lens to focus at that distance. Simple cameras can only focus on a limited number of distance zones, and the camera sets the one closest to the measured distance. Sophisticated cameras have more zones, or can focus on any point from about 30 cm (12 inches) or closer to infinity.

Passive AF

This is used by more advanced cameras, and focus is achieved by the camera examining subject edges within the image and adjusting the lens to make them as sharply defined as possible.

Left: The closest object is usually assumed to be the main subject.

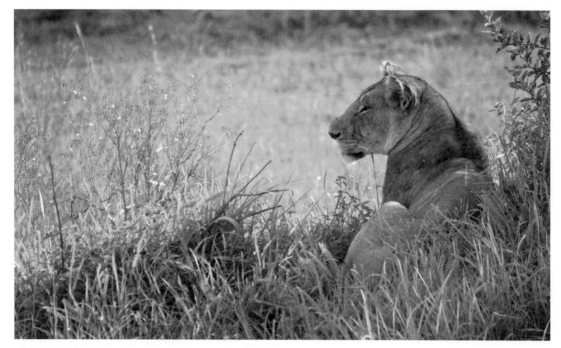

Above: Today's cameras can shoot even distant subjects in perfect focus.

FOCUSING ON THE SUBJECT

In both cases, the camera has to guess which of the many elements in your picture constitutes your main subject. It generally assumes that it is the closest and most central object in the frame and focuses on that, and nine times out of ten it is correct.

Focus Lock

Simple cameras measure distance from the centre of the frame, so if your subject is off-centre, the camera may look past it and focus on some more distant object. One way to avoid this is to use the focus lock, which almost all cameras have. This involves

Hot Tip

If pressing the shutter halfway down identifies an unintended focus point, most cameras will allow you to repeat the process to realign the focus.

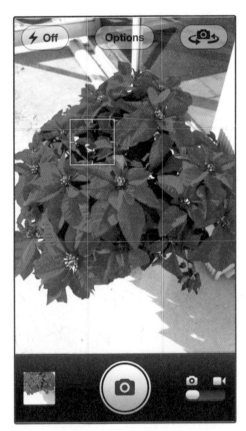

Above: Some smartphones now allow you to tap the screen to move the focus to a particular area.

Hot Tip

If you're more interested in landscape than the faces within the shot, facial recognition can often be turned off in the settings.

pointing the central point at your subject, pressing halfway down on the shutter button and holding it there, then repositioning the camera before taking a picture.

Multiple Focus Points

Some more advanced cameras avoid the need for focus lock by employing several focus points dotted around the frame – in fact several dozen, in the case of some Single Lens Reflex cameras (SLRs). These measure the distances of all the elements in the frame, and complex algorithms then work out which one is the subject. It is also usually possible to manually select between the various focus points if you feel the camera needs some help. If an off-centre subject has much higher contrast than a central one, the system may be fooled.

Face Detection

Most cameras now have a helpful AF assist mode that recognizes when faces are in the frame. And, when faces are in the frame, it's likely they're your subjects. With this mode enabled, you'll see boxes hovering around the faces. Naturally, this means the camera is zoning in on those faces as the focal point of your shot.

Tap to Focus

One of the advantages of taking photos on smartphones is the advanced touchscreen technology, which also now exists on some compact cameras. While most phones will have perfectly adequate autofocus

technology, others will allow you to tap any point on the screen in order to inform the lens where you'd like it to focus. Most new phones have powerful processing technology that'll make this adjustment very quickly.

CAPTURING MOTION

All cameras use, by default, a 'single shot' focus method, where once the camera has locked on to the subject and focused, it will stay at that point until you either take the shot or let go of the shutter button. This is fine for static subjects, but for moving subjects, most cameras offer a 'continuous AF' mode, whereby the camera keeps refocusing as long as your finger is half-depressing the shutter, and you can fire at any time, whether the subject is in focus or not.

Below: Moving subjects can be shot in focus in 'continuous AF' mode.

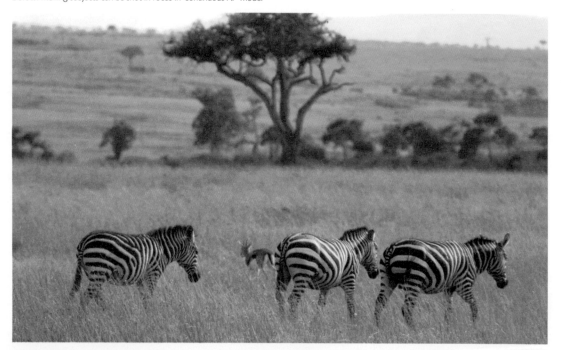

DEPTH-OF-FIELD TECHNIQUES

To exert maximum creative control over the visual appearance of your picture, it is essential that it is you who is telling the camera what to focus on, not the camera telling you.

Above: You may not always want the background to be in focus.

TAKE CONTROL!

In order to tell the camera what to focus on, try using the focus lock (*see* pages 97–98), changing the focus mode, or perhaps leaving the comfort zone of AF altogether in favour of manual focusing. This is more difficult with compacts, but some models enlarge the central portion of the LCD to aid accuracy. With SLRs, of course, manual focusing is simple and straightforward – just a bit slower than AF.

Manual Focus

With SLRs and some mirrorless cameras, you can easily switch your camera to manual focus. Some cameras have an AF/MF button on the body, while on others it can be accessed through the menus. Using manual focus requires you to turn the focus ring on the lens in order to refine what it concentrates on.

Hot Tip

It is much easier to use manual focus when viewing the subject through a viewfinder rather than watching an LCD display.

WHAT TO KEEP IN FOCUS

Creative control is not just about the point of focus, it is also about the depth of the zone of focus. In other words, how much of the scene in front of and behind the main subject do you wish to be sharp? The answer may well be 'all of it', especially in the case of landscapes, where you may want everything from the foreground flower to the horizon crisply sharp. But with a portrait, for example, do you really want to the background to be sharp enough to distract from the main subject?

Depth of Field

This zone of focus is known as the depth of field, and deciding how much you want is one of the most important creative decisions you will make. A shallow depth of field is ideal for

Above: A shallow depth of field allows you to focus on the foreground.

making your subject stand out from its surroundings, such as drawing attention to a single flower in a field, or a single face in a crowd.

APERTURE VARIATIONS

The depth of field is controlled by the size of the lens aperture. The smaller the aperture (i.e. the higher the number), the more depth of field you will get. The wider the aperture, the shallower your depth of field will be.

> ## Hot Tip
>
> **Some cameras have a neat 'background defocus' mode that allows you to control how sharp the image remains beyond its focal point.**

- **Depth of field** extends both in front of and beyond the point focused on, in the ratio of one third in front and two thirds behind for distant subjects, and half and half when you are very close to a subject.

Above: Both the foreground and the horizon are in focus using a small aperture.

Above: You can also focus on the middle distance.

○ **The exact amount** of depth of field you will achieve depends on several variables in addition to the relative size of the aperture.

LENS VARIATIONS

Larger image magnifications reduce the depth of field, while smaller image magnifications increase the depth of field. So longer focal length lenses (i.e. telephotos) provide less depth of field at a given aperture, while wide-angles provide much more. Equally, the closer you are to your subject, the less your depth of field will be, so at a given aperture, your depth of field will be much shallower at 15 cm (6 in) than 2 m (6 ft).

○ **Use a wide-angle lens** at a small aperture focused far away for the maximum depth of field.

○ **Use a telephoto lens** at a wide aperture close up to give the shallowest depth of field.

EXPOSURE MODES

Left to their own devices, cameras measure the light and set the exposure without any intervention from the photographer.

THE MAIN EXPOSURE MODES

All but the most basic models offer a variety of exposure modes; each of the modes employ different criteria in deciding which of the various settings to select. Some are fully automatic, others require some input from the photographer. Here is a brief runthrough of the main modes:

Auto Mode

In the auto mode (usually marked in green), the camera takes care of everything. Not only are you not required to make any decisions, in most cases, you are prevented from doing so.

Program Mode

The camera still does everything, but it does offer you some degree of override. For example, it is usually possible to apply exposure compensation

Above: A landscape mode would be ideal here.

(subtly increasing or decreasing the exposure an image receives), alter the shutter speed/aperture combination using program shift (which still keeps the overall value the same), or switch the flash on and off.

Shutter Priority

This is a semi-automatic mode, in which you have to choose which shutter speed to use, and the camera then matches it with the corresponding aperture that will provide the right exposure in the prevailing conditions. This mode is ideal when photographing moving subjects. You can choose a fast shutter speed to freeze the movement, or a slow one to blur it.

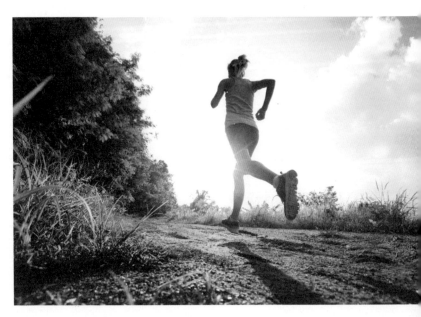

Above: Shutter priority allows you to capture motion.

Aperture Priority

In this mode, you select the desired aperture and the camera sets the necessary shutter speed. So if you want a shallow depth of field, pick a wide aperture and the camera will set a fast shutter speed. As you stop down the aperture to get more depth of field, the shutter speed will automatically increase in duration to compensate. Please note that you need to ensure that the camera can set a shutter speed within its range given the aperture you have selected.

Hot Tip

You need to check that the selected shutter speed is able to deliver the correct exposure with the available aperture range.

Manual Mode

In this mode, you set both the aperture and shutter speed, based on information provided by the exposure meter. This mode is useful for shooting panoramas, when you want every exposure in a sequence to be the same, and do not wish any frames to be influenced by any dark or light bits in the scene. Studio photography is another situation where manual is best. The meter will still show its recommendation; you need to decide whether to ignore it or not.

Scene Modes

Sometimes called subject modes, these are a selection of preset modes covering a variety of types of subject. Common examples are landscape, portrait, sport and night modes, but you

Above: Many cameras have a preset 'beach' mode.

can also get special modes for beaches, skiing, parties, text, etc. In each mode, the parameters are optimized for the subject. This may include things such as the ISO and white balance, as well as the shutter speed and aperture.

High Dynamic Range

In some lighting conditions the ratio of contrast between the darkest shadows and brightest highlights is too great for the camera's sensor to record, meaning that detail in one or the other will be lost. When HDR mode is enabled the camera records more than one exposure to capture detail in both highlights and shadows, then blends them together. This can also be done manually, using dedicated software on the computer.

Hot Tip

The HDR mode is perfect for capturing high contrast scenes.

Above: HDR mode can create stunning sunset photos.

PHOTOGRAPHING MOTION

The aperture controls the intensity of the light reaching the sensor, and the shutter speed determines the duration of the exposure.

SHUTTER SPEED

Most SLR shutters are of the focal plane type, which means that they comprise of two vertical or horizontal curtains. The first one opens to expose the sensor, then the second one closes behind it to end the exposure. The time delay between these curtains determines the shutter speed.

Above: Experimenting with the aperture and shutter speed can produce exciting results.

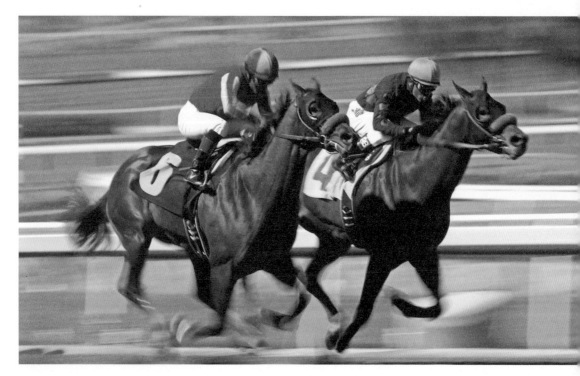

Above: Panning mode can be used when watching sports.

At high speeds, the second curtain must actually start to close before the first one has completed its journey, creating a moving slit which travels across the frame; the faster the speed, the narrower the slit. This has an effect when using flash (*see* pages 118–121).

CAPTURING MOVEMENT

With moving subjects, the longer the shutter is open, the more the subject will have moved across the frame during the exposure, creating a blur as it does so. At fast speeds, the narrow slit moves so quickly that only a fast-moving subject will have time to move across the width of that slit before it is moved on to expose the next band of the scene.

Don't Freeze The Motion

If you want to record a moving subject in sharp focus, you need to set a fast shutter speed – and the faster the motion, the faster the shutter speed needs to be. However, you may not always want to 'freeze' the motion. With some subjects, such as racing cars, the target can look stationary rather than 'frozen in time', thereby destroying any sense of motion and dynamism. Sometimes it is best to deliberately allow the moving subject to record as a blur, by a controlled amount, to show that it was moving. In these situations, a slower speed will be required.

Above: Burst mode allows you to take lots of photos consecutively.

- **Panning**: A third option is to use a slower speed, but move the camera in time with the subject so it stays at the same point in the frame. The subject will remain relatively sharp, but the background will be blurred by a streaking motion. This technique is known as panning.

BURST MODE

Most cameras and smartphones now have a continuous shooting or burst mode which can be useful for capturing motion. It can be accessed through the menu and then users can simply keep their finger on the shutter in order to take multiple photos per second. In some cases, all the frames can be turned into short videos, a little like digital flickbooks.

TRIAL AND ERROR

It's difficult to suggest specific shutter speeds for specific moving subjects because there are so many variables, including the speed and direction of travel, distance from the lens, and of course the degree of blur or sharpness required. The big advantage of digital is the ability to experiment and see the results immediately, so it won't take long to ascertain the optimum speed in a given situation, simply by trying a few of them out and reviewing the results.

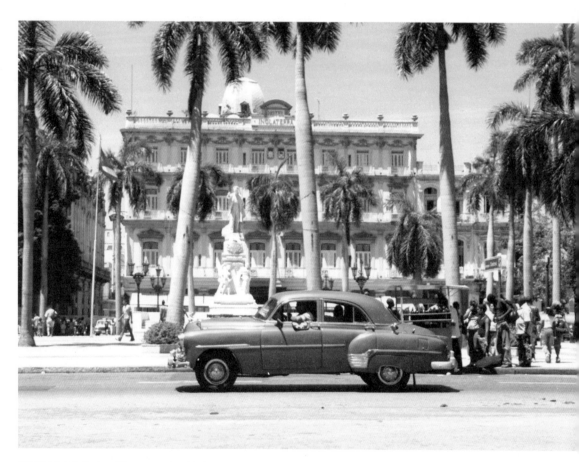

Above: A fast shutter speed freezes a moving object.

LIGHT

The word 'photography' comes from two Greek words, and means 'drawing with light'. It is the perfect name for the medium, because photography is all about light, and without it, there would be no photographs.

QUALITY NOT QUANTITY

To take a great picture, photographers need more than merely a sufficient quantity of light: they need good-quality light, and this is much more important than the quantity.

The quality of light is a combination of the size, distance, direction and colour of the light. These various qualities guarantee an almost infinite combination of lighting effects, which, in the case of natural light, are constantly changing.

Hot Tip

The human eye barely notices subtle changes in natural light, but the skilled photographer must learn to understand and manipulate them.

Hard and Soft Light

The size of a light source has perhaps the strongest influence on the quality of illumination.

- **Hard Light:** The smaller the source, the 'harder' or higher contrast the light falling on the subject will be – it becomes an intense, brightly lit area surrounded by very deep shadows. The distance is another determining factor. As a light source moves further away, it becomes smaller, and therefore harder in quality.

- **Soft Light:** One way to make the light source larger is to diffuse it. Outdoors this is achieved by clouds. On an overcast day, the sun is hidden by cloud, so the entire sky becomes one big, soft light source. The illumination it creates is virtually shadowless.

In the studio, photographers use all sorts of devices to modify their lights to achieve a similar effect, such as softboxes (translucent tents through which the light is fired) or umbrellas (white or silver to bounce the light back on to the subject).

Light Direction

As well as the size and hardness of the light, photographers must pay attention to its direction. For even, frontal illumination there's a rule that says photographers should keep the light source (sun or otherwise) behind them, so it lights the part of the subject that is facing the camera. While there is nothing wrong with that, the result can look a little boring creatively.

Above: Shadows and bright light can combine to great effect.

Above: Soft afternoon light can make a beautiful photo.

Hot Tip

Sometimes it is more interesting (yet also more challenging) to capture a subject when the light is coming from elsewhere rather than facing the subject.

Colour Temperature

The final factor that determines light quality is its colour temperature. Colour temperature is typically recorded in degrees Kelvin, the unit of absolute temperature. Cool colours, like blue and white, generally have colour temperatures over 7,000 K, while warmer colours like red and orange lie around the 2,000 K mark.

- **Natural Light:** Daylight is constantly changing in colour, though we rarely notice it. First thing in the morning, and again at dusk, it is at its warmest (i.e. its most yellow-orange).

Above: Seasons will also have an effect on the natural light colour.

At midday, it is bluest. Atmospheric conditions affect things too – a cloudless blue sky produces a bluer light on the ground, for example, than direct sun.

- **Artificial Light:** Artificial light is a completely different colour. Traditional tungsten filament light bulbs produce a very orange light compared with daylight, and fluorescent tubes can often add a greenish tinge that is rarely attractive. Digital cameras control this light colour with a function called the 'white balance', and with most cameras it adjusts automatically (just as our eyes do).

The Right Light

There is no right or wrong type of light – only what is right or wrong for a given subject. Landscapes, for example, are often at their most alluring when the light is low, hard and from the side, or you are shooting into it. The long shadows this creates add shape and contour to the land. Beauty portraits are almost always lit by soft, shadowless light, as harder light will emphasize any wrinkles or blemishes in the skin.

Hot Tip

Most cameras also offer manual white balance presets for when the auto setting is wrong, or for when you wish to override the camera's choice.

Above: 'Harder' light can also result in an impressive picture.

ISO SENSITIVITY

Photographers often talk about there being enough light to take a picture. This means sufficient brightness to take a picture without the risk of camera shake – that blurring of the image caused by our natural and unavoidable body movement during the exposure.

Above: A blurred effect in low light can sometimes make for a great picture.

SAFE SHUTTER SPEED

At higher shutter speeds, this movement is not noticeable in the picture, though the threshold depends on many factors, including the steadiness of the individual and the choice of lens – the greater the zoom magnification, the higher the speed needs to be to avoid shake. Generally, with a lens at the standard (non-zoomed) position, the minimum safe shutter speed is around 1/60 sec, but this rises significantly as you zoom. Some people are also more prone to shaking than others, and it's worth doing some tests to see what your safe shutter speed is.

Other Options

That works when there is enough light for the camera to set that speed (and with program modes, it will always try to) but what happens when the light fails? Or what if you need to use an even faster shutter speed to capture a

Hot Tip

The last option is always to increase the ISO setting.

moving subject, which pushes the shutter speed below that threshold? Automatic cameras will turn on the flash, which you may not want, and which doesn't work with distant subjects anyway. Another option is the tripod.

ADJUSTING THE ISO

In the days of film the ISO (formerly called ASA) was a measurement of the sensitivity of film (i.e. how much light was required to record an image). Film came in different sensitivities, but the faster (more sensitive) the film, the more grainy it was. The sensors of digital cameras work in a similar way. In most cameras, the default sensitivity is ISO 100. You can raise the sensitivity of the sensor to at least ISO 3200 and often much higher.

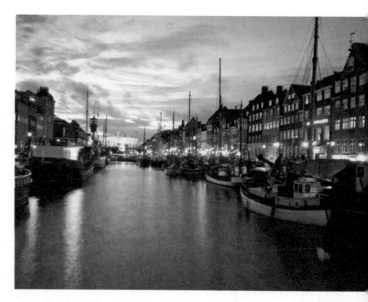

Above: Use a high ISO setting to capture sharp images in low light.

Image Quality

However, the higher the ISO, the more the image quality suffers. This is because in order to raise the sensitivity, the camera amplifies the electrical signals from the sensor, and also therefore amplifies the 'noise' (non-signal impulses). Noise can take many forms, but often shows up as a blizzard of tiny, multicoloured dots, most visible in dark areas and areas of continuous tone. It is intrusive and unattractive, destroys fine image detail and lowers contrast.

Hot Tip

It is always best to use the lowest ISO setting that conditions will allow – even if that means using a tripod.

FLASH

When the light level drops to a point where it is no longer safe to take a picture without risking camera shake, most cameras automatically switch on the flash. This is fine for emergencies, but unfortunately, flash is not always the best solution – and the result is often disappointing photos.

HOW THE FLASH WORKS

Flash spreads out over distance, and only has a very limited effective range. Double the distance, and the intensity of the light hitting a given point drops by a factor of four. If not enough light reaches the subject, the resultant image will be underexposed. Built-in flashguns are usually very small, so you have only got a very small intensity to start with.

Above: Flash has a limited range, but eliminates camera shake.

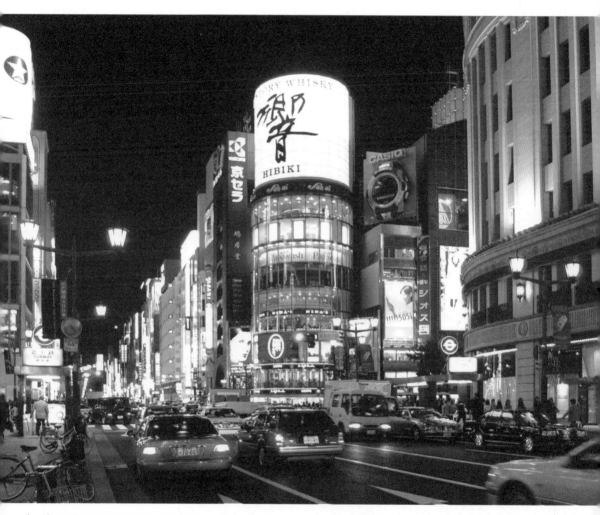

Above: Flash is useless for subjects beyond about 4 metres.

The maximum range is 3–4 m (10–13 ft). Beyond this, flash is largely a waste of battery power. Increasing the ISO also increases the usable flash range – double the ISO setting and the flash range increases by a factor of 1.4. Switch from ISO 100 to ISO 400 and you double the range.

Within its specified range, using a flash will give you a picture, but it may not be a flattering one. It can also cause 'red eye'. In low light, our pupils open wide to let in as much light as possible, and flash entering the eye from the camera position illuminates the blood vessels on the retina and reflects back through the lens. Anti-red-eye settings can reduce this problem, but it should be remembered they are red-eye reduction, not red-eye elimination functions.

Cameras provide a selection of flash modes for the optimum result:

Left: If shooting with flash off, you will need a steady hand.

Auto

The camera does all the thinking. Fine for party pictures (except for the red eye), indoor gatherings, etc.

Auto with Red-Eye Reduction

This can reduce red eye, but the delay it causes between pressing the button and the picture being taken often results in unnatural expressions and is generally more trouble than it is worth.

Above: Using auto flash is perfectly acceptable for everyday use.

Slow Sync Flash

In auto flash mode, the camera sets a shutter speed of 1/60 sec or faster, which reduces the dim available light to a sea of blackness. If you want to show something of the environment in which you are shooting, slow sync flash combines the flash with a slow shutter speed to record the ambient light – though you will need to rest the camera on a stable surface and ask people to keep still to avoid blurring.

Flash Off

Sometimes flash is prohibited (such as in museums and in some public places) so you should set this mode to override the camera's natural instinct to turn it on. In this mode the camera sets a longer shutter speed, so you will need to find something stable to support it.

Flash On

(Often called 'force flash'.) Fires the flash even though the camera does not think it is necessary. Some cameras will have a flash option next to the function buttons, where you can toggle it on and off. Others will require you to go through the settings.

Hot Tip

Direct flash is harsh and, when the background is dark, can lead to very washed out faces.

VIEWING YOUR PHOTOS

CONNECTING CAMERA TO COMPUTER

Digital photographs are stored on interchangeable memory cards or in the camera's internal memory. To edit, manage and archive them, you need to transfer them on to a computer from the camera (*see* also pages 143–144).

WIRED TECHNOLOGY

The transfer process varies slightly, depending on the make and model of camera. The majority of digital cameras are supplied with a USB cable, which connects to the camera and plugs into a port on your computer. You can then transfer images by following the instructions displayed on the LCD screen.

Below: A memory card reader is a handy tool to have.

USING A MEMORY CARD READER

Memory card readers are one of the most straightforward methods of transferring images from camera to computer. You connect the reader to the USB port on your computer and insert the card into the slot. Some computers even have a built-in slot for SD cards. A wide range of readers are available that are

compatible with singular or multiple types of flash cards. The reading devices are usually small enough to stay permanently attached to your computer. They're also small enough to fit in your photography bag or camera case with ease.

USING A DOCKING STATION

It's less common these days, but some digital cameras are supplied with a docking station that connects to your computer using a USB port. Once you activate the dock, the images are uploaded directly to your computer. Docking stations can stay permanently connected to your computer, making them a convenient option.

USB

USB (Universal Serial Bus) technology has become a common way of connecting external devices like cameras to a computer, using a cable to link between the two gadgets. Many cameras now use the USB 2.0 format, which offers a data transfer rate of transfer of up to 480 Mbps (megabits per second). That makes it possible to transfer a large batch of photos to your computer in just a few seconds.

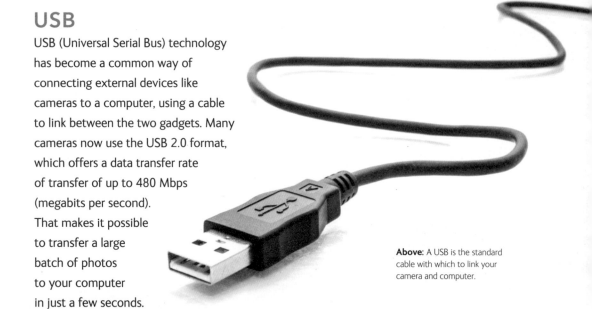

Above: A USB is the standard cable with which to link your camera and computer.

Micro USB

Most modern cameras, smartphones and tablets have a Micro USB port (or Lightning port in the case of Apple devices) to connect to a power source or to a computer. Some cameras, usually smaller compacts, can be charged up by plugging into a computer. MicroUSB has a much smaller connector, which allows gadget makers to save space when building cameras.

Hot Tip

If you have a variety of mobile gadgets, you'll likely acquire a lot of Micro USB cables. The tech is universal, so you can use any of them with your camera.

○ **USB 3.0**: In recent times, USB 3.0 has been introduced, which in theory can hit 625 Mbps transfers, although the technology is yet to graduate to most cameras.

Above: Wi-Fi hotspots can be found in many places out and about.

WIRELESS TECHNOLOGY

It is not always desirable to have cables cluttering up a desk, and wireless standards are becoming increasingly popular. The three main types of wireless communication are Wi-Fi, mobile internet data (like 3G and 4G) and Bluetooth.

Using Wi-Fi

Connecting to Wi-Fi networks allows users to freely share files over the internet, often transferring them to another device.

Using Mobile Data

Mobile data allows the same, but the data is usually part of a mobile phone contract and is often metered. Few dedicated cameras have access to mobile data, it is more applicable to smartphones.

Using Bluetooth

Bluetooth is a proximity-based standard that allows two pieces of technology to communicate and exchange date while in range. Most computers, smartphones and some cameras are Bluetooth enabled.

WHICH WIRELESS TECH SHOULD I USE?

- **Wi-Fi:** This is suitable for high-resolution snaps with large file sizes, such as those taken on DSLR cameras.

- **Mobile data:** This option is better for sharing the odd photo via email, or to social media.

- **Bluetooth:** This is often suitable when transferring smaller files, such as pictures taken on mobile phones, to computers and printers. However, Wi-Fi is more suited.

Wi-Fi Radio

Many cameras are now equipped with a Wi-Fi radio that allows easy connection to the internet, while many have built-in software that facilitates the file transfers. It can be used to send photos to computers and printers on the same network, or to send pictures directly to the internet or to social media, where they can be safely stored and shared.

SET ICONS OF ELECTRICAL

Hot Tip

Whenever available, use a Wi-Fi connection rather than mobile data to send pictures. It'll save your all-important data allowance for when you need it.

Above: Many cameras can now connect to other devices wirelessly.

ACCESSING AND TRANSFERRING IMAGES

Once you have connected your camera or your memory card to your computer, you'll be able to access the photos directly through the Windows or Mac operating system.

ACCESS USING WINDOWS

If you use Windows an icon appears on the My Computer interface entitled Removable Disk.

Above: On a Mac an icon will show up on your desktop when your camera is connected.

ACCESS USING A MAC

If you use a Mac an icon for the device (with a generic name depending on your camera) should appear on your desktop and in the Finder window. One way to access your photos is by clicking on this and browsing to a folder called DCIM which means (Data Center Infrastructure Management), where all of your images sit. The name varies between different manufacturers, but will include a sequence of numbers and letters such as '100OLYMP' or '729 CANON'.

Above: You can import your photos into iPhoto, which will allow you to edit and sort them.

Hot Tip

To import specific photos, identify the thumbnail and 'drag and drop' the file into your chosen folder.

TRANSFERRING THE IMAGES

To transfer the images from you camera to your computer, drag the folder directly on to your desktop or to a specific location such as the Windows My Pictures folder (called Pictures on Mac). A pop-up box will appear to inform you of the transfer's progress.

USING BUILT-IN COMPUTER SOFTWARE

In many cases there's an easier way to import photos. On both PC and Mac, software like Photo Gallery for Windows and iPhoto on Mac OS X will automatically open whenever you plug in your camera or memory card. These programs are perfect for storing your photo library, will present options to import photos from your camera, will allow you to perform edits to a

Hot Tip
Got an iPhone or a Windows Phone? These programs will also automatically import photos taken on handsets rather than having to transfer manually.

Right: Photo Gallery can be used to store your photos on a PC.

reasonably high standard, make slideshows and even share photos with friends and family via email or on the web. When you plug in your camera, if installed, Photo Gallery or iPhoto should be the default method your computer offers you for importing photographs.

USING CAMERA SOFTWARE

Newcomers to digital photography may find it easier to access their photographs using the software supplied with their camera. Connect the camera to the computer, fire up the program and follow the onscreen instructions to locate the pictures and transfer them on to your computer's hard drive (its main storage area).

WHERE ARE THE IMAGES STORED?

If you're a Windows user, photos imported using the aforementioned Management tool can be accessed through the My Pictures folder (unless you specify otherwise) iPhoto images are stored in the iPhoto Library, which is within the Pictures folder on your Mac.

Hot Tip
Avoid playing around within the iPhoto Library folder. Everything you need to achieve can be done from the app itself.

TRANSFERRING PICTURES FROM PHONE TO COMPUTER

As well as the dramatically improving quality of the sensors and lenses, one of the reasons smartphone cameras are beginning to replace dedicated cameras is the abundant connectivity and sharing options.

NO WIRES, PLEASE!

While a camera must usually be plugged into a computer physically or its card removed and inserted into a card reader, images from camera phones can also be shared and transferred instantly to a variety of locations in many of the ways explained earlier in the chapter: via Bluetooth, Wi-Fi or mobile data (*see* p. 126)

Left: You can easily share your pictures quickly using social media apps.

MEMORY

Unlike dedicated cameras, most sophisticated smartphones come with user-accessible, built-in storage, which can be used to store apps, music, movies and, for our purposes, lots of lovely high-resolution photos. Apple iPhones and some high-end Android phones can have up to 64 GB of storage. That's literally thousands of photos.

Micro SD Cards

If phones don't have large hard drives, they can often be supplemented with Micro SD cards, fingernail-sized cards that promise the same amount of storage. They can be added and removed to some compatible devices to

Above: Micro SD cards can be added to smartphones to allow you to store more images.

supplement the built-in storage, although not with iPhones. Many card readers have Micro SD slots, although plugging the phone into the computer via USB will also enable you to access the contents of the memory card.

Hot Tip

SD card adapters are available that allow you to plug in Micro SD cards before connecting to the computer.

HOW TO OPEN A PHOTOGRAPH

Once you have taken your pictures and transferred them on to your home computer, you will want to open them. There are several ways to do this.

OPEN THROUGH THE EXPLORER OR FINDER WINDOW

Here's one of the easiest ways to open photos on your computer:

1. Navigate to the folder on your computer to which you have transferred your photos.

2. Within this window, called 'Explorer' in Windows and 'Finder' on Macs, you should be able to see smaller thumbnails of your images, which are smaller versions of your photos, but large enough to determine which is which.

Above: You can open photos on a Mac from the Finder window.

3. From this window, you can double click a photo to open it within the default photo viewing software for your computer. On a Windows 8 PC, it will usually be the Photo Viewer app. On Macs, images will open by default in Preview. (Both are designed mainly for viewing images, but you can also zoom, rotate and access a few other simple commands.)

Above: You can make simple edits to your photos using the Photo Viewer app.

4. If your photos are the wrong orientation you can quickly turn them right-side up, and for more detail you can zoom in and out.

5. You can also cycle through images (if you're opening more than one), share them elsewhere, send them to print and more.

Above: Photos can be cropped in Adobe Photoshop Elements.

OPEN USING IMAGE-EDITING SOFTWARE

If you are intending to perform specific image-editing functions (such as cropping or adjusting the brightness and contrast), it may be better to open photos directly within an editing program, such as Adobe Photoshop Elements. Here's how to do it:

1. Open the software and click the File menu, then select Open.

2. A box will appear that you can use to access the files from their current location on the computer.

3. A file browser also views the contents of a folder as thumbnails with information telling you when each picture was taken and the camera settings used. This is particularly useful to identify a specific photograph when you have numerous pictures in the same folder, and you can view them all at the same time without having to open them individually.

CHANGING THE DEFAULT PROGRAM

You can also change the default programs your computer uses to view photos:

⊙ **In Windows**: Right-click an image, scroll down and select 'Open With' and click 'Choose Default Program' for the list of options.

⊙ **On a Mac**: Click a photo file, hit Control+I for 'Get Info' and scan down to 'Open With' to change the default program.

Above: Changing the default program that opens your pictures is simple to do.

ORGANIZING YOUR IMAGES: NAMING & FILING

The immediacy of digital photography means that more people are taking more photographs then ever. Unless you have some organization, your hard drive will soon be overrun with photographs all with impenetrable file names, so it is useful to implement a filing system.

RENAMING YOUR PHOTOGRAPHS

Once you have transferred your images on to your hard drive the first thing to do is replace the file extension generated by the camera – this is generally a sequence of numbers like 1010080 or IMG_4309 that offers little useful information – into something comprehensible.

Above: Organizing your photos will make them easier to find when you want them.

Above: Renaming photos will make it easier to search for images.

Auto Renaming

It is labour-intensive to change the names of numerous digital files individually. Adobe Photoshop Elements 9 has a tool that can rename all files within a folder. Hit File and select Process Multiple Files. Choose the folder by hitting Source. Then you can scan down to Renaming Files, enter a name – such as 'Summer Holiday 10' – and it will be allocated to each photo along with a sequential number.

FILING YOUR PICTURES

If you're not using a library management tool (*see* pages 138–141), it is a good idea to have a system of folders in place to which you can transfer images once you have renamed them.

Named Folders

The most straightforward method is to create a series of named folders for different types of photographs, including holidays, birthdays and pets. Within each genre of photographs, you can include sub-folders that are more specific, for example 'Tenerife 2014' or 'Sarah's 14th'.

CREATING A PHOTO LIBRARY

While manually organizing your photographs into folders (as described previously) may work for a hundred images, if your digital photographs run into the thousands, it is more practical to create a photo library using specialist software.

FREE SOFTWARE

There are a wide variety of options available on the market, but thankfully, both Mac and Windows computers have very capable, free programs available for your computer. Both pieces of software make it easy to import your photographs, make simple edits and create slideshows.

PHOTO GALLERY APP FOR WINDOWS

The built-in Photos app for Windows 8 is suitable for viewing photos in different locations (Facebook, My Pictures Folder, OneDrive, etc.), but its functionality is limited. Thankfully Microsoft has created a more advanced management tool called Photo Gallery, which is a free download as part of Windows Essentials 2012.

Left: A photo library can be a great tool.

What Can You Do With It?

- **Import**: This app automatically recognizes snaps in your My Pictures folder and allows you to import your photos from a camera, phone or other device.

- **Organize**: From here, you'll be able to organize/group the photos into albums, tag your friends and family and search your library by name (for example, search 'dad'), date and location keywords (if your camera has geotagging enabled).

- **Edit**: You're also able to access editing tools like cropping, straightening, colour, exposure, red-eye correction and more.

- **Share**: It'll even let you share photos via email, the web and social media directly from the app.

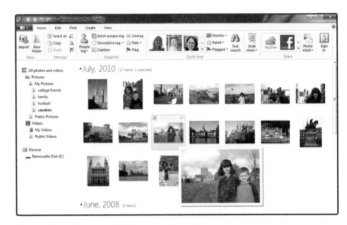

Above: Photo Gallery App for Windows is definitely one to get.

Hot Tip

If your camera or mobile device has its geo-tagging setting enabled, you'll be able to pinpoint exactly where you took those precious photos and in many cases view them on a map.

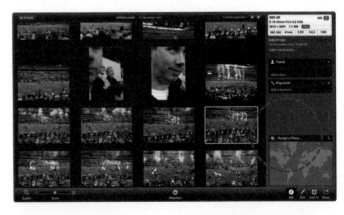

Above: In iPhoto, you can list the places you took your photos, for future reference.

iPHOTO FOR MAC

iPhoto has been the staple photo management tool on Mac computers for quite some time. It is the default app for importing photos when you plug in a memory card, camera or mobile device.

What Can You Do With It?

- **Import**: Handily, it detects which photos are already in the library and asks you to import the new ones. It will group these imports as Events, based on the date you imported them. You can name Events or merge them together.

- **Create Albums**: You can also select specific photos to create Albums, which can then be turned into Photo Books if you desire.

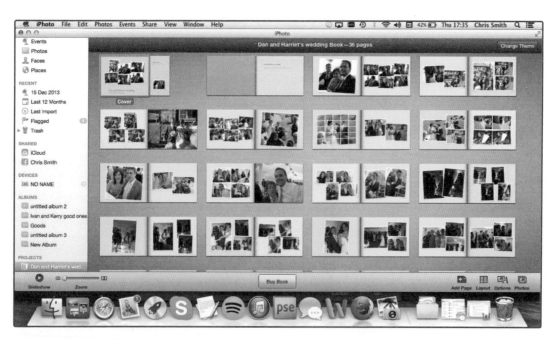

Above: You can easily create a photo book in iPhoto.

○ **Tag Friends**: With iPhoto, you can also tag friends and view all pictures of them through the Faces tab.

○ **Locate**: Places allows you to view where your photos were taken, on a Map.

○ **Edit**: It also features a host of relatively powerful editing tools, allowing you to make quick fixes like rotating, cropping and straightening, while also adding effects and adjusting colour levels, exposure, contrast and more.

Hot Tip

If you're an iPhone user, iPhoto will automatically pull in photos from your phone when you're connected to the same Wi-Fi network via iCloud.

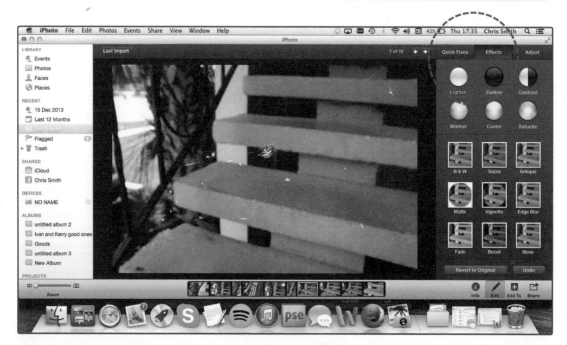

Above: You can edit your photos in iPhoto with effects and simple fixes.

○ **Share:** Naturally, you can share photos via Facebook, email or Flickr and more, while also creating attractive full-screen slide shows.

USING KEYWORDS

Keywords are a great way to keep track of your photos on your computer's hard drive, making it easy to bring together photos in a similar vein. For example, if you enjoy taking photos of sunsets, labelling all of those photos with the appropriate keyword will enable you to pull them up at the same time.

How To Add Keywords

In Photoshop, you can add keywords by selecting File > File Info and choosing your words. Multiple keywords can be added to photos. If you're using Photo Management tools you can add keywords for albums, events, photos and more, making them easy to track down via the search tool. To find your desired photo, enter the keyword, which could be a birthday, holiday or day out, the name of the person in the picture, or even a photographic genre such as travel, nature or macro.

Below: In the Windows Photo Gallery app, you can choose to edit or share your photos.

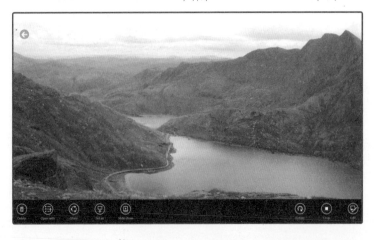

PROGRAM BONUSES

As we've mentioned, many image-management programs act as all-in-one solutions for your photography needs. Both Windows Photo Gallery and iPhoto are serviceable for simple edits and sharing of your photos without having to use different programs.

LIVING WITHOUT A COMPUTER

You can tinker with your digital photographs on a computer to enhance them or create something artistic, and while many people will invest in a computer, it is a myth that you need one in order to enjoy digital photography.

TOUCHING UP IMAGES

Plenty of camera manufacturers have introduced technology into their cameras that can be used for rectifying common photo problems, which means some edits you perform on a computer can now be done in-camera. This means the lighting can be adjusted after the fact, red eye can be corrected, you can balance colours, straighten images, and even add creative effects like colour filters. If you use a smartphone or an Android-based compact camera like the Samsung Galaxy S4 Zoom, the world is your oyster.

SHARING IMAGES

In the past, photographers wishing to share their photos on the web or with others would need to transfer to a computer first. Now an increasing number of cameras are packing Wi-Fi connectivity, meaning you can share photos all over the web without troubling your computer.

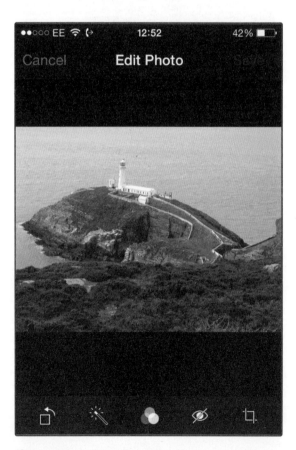

Above: Images can also be edited quickly and easily on a smartphone.

Above: This Samsung NX3000 has Wi-Fi capabilities.

Above: The majority of printers now have a place for a memory card.

PRINTING WITHOUT A COMPUTER

Printer manufacturers are increasingly recognizing that not everyone wants to use a computer. As a result, most modern printers are Wi-Fi and or Bluetooth enabled, which means in some cases, you'll be able to send images directly to print over the airwaves.

Other printers allow you to hook your camera up to the printer itself using the USB cable or simply slide the memory card into a built-in reader. In those cases, instructions will appear on the LCD, asking which photographs you want to select and how many copies you want to print. If you don't have a printer or don't wish to print your own pictures you can take your memory card to a photo developer. Specialist photographic retailers such as Jessops and even supermarkets can produce prints directly from a memory card. (*See* pages 201–202 for more on printing labs).

Hot Tip

If you're using an Apple device, the AirPrint feature will allow you to print directly from your iPhone or iPad with a compatible printer.

ARCHIVING YOUR PHOTOS

Unfortunately, computer errors do occur, and the only way to cope with this happening is to create back-up copies of your photographs by transferring them on to a portable storage device or burning them on to CD, which you should keep separate from your computer. You can also back them up online, in the cloud.

HARD DISK DRIVES & STORAGE DEVICES

The most common means of backing up is to make a copy on an external USB hard drive or storage device such as those made by LaCie or Western Digital. These connect to your computer via a USB cable and mount on your computer desktop. Simply drag and drop the files you wish to save. These hard drives have come down significantly in price in recent years, meaning you can acquire a large, high-quality drive with a terabyte (1,000 GB) of space for much less than £100/$100. It's definitely a worthwhile investment if you value your photo library. The only foreseeable problem with external hard drives is, just like the one sitting within your computer, it can fail, taking your photos with it.

Left: This storage device from LaCie can store or back up all of your photos.

BURNING A CD OR A DVD

If your computer has a disc burner, keeping disc-based copies of your photos in case calamity strikes is a saving grace. You can choose to burn your photos on to CD or DVD:

- **Conventional DVD/CD-Rs**: These can only be used once.
- **DVD/CD-RWs**: These can be used more than once.

CDs are cheaper and are good for a smaller number of photos, but you can fit far more photos on a DVD because it provides the advantage of 4.75 GB of storage per disc in contrast to the 700 MB offered by a CD. While DVDs will take longer to burn, they allow much more storage, particularly if you have saved images as TIFFs or kept RAW files.

Here's how to burn a disc:

1. Insert the blank disc into the burner and either follow the instructions offered by the burning software on your computer, or copy and paste the files in question on to the disc. It will let you know how much space has been used and how much is still free.

> ## Hot Tip
> Once the burn is complete, eject the disc and use a marker pen to etch the date and the photos contained within.

2. Once the transfer is complete, within the folder there'll be a 'Burn Disc' option to get things started. Within a couple of minutes, you'll have a physical back-up of your photos.

BACKING PHOTOS UP TO THE CLOUD

We'll discuss sharing photos on the internet in much greater detail in Chapter 5, but while we're on the subject of archiving, it would be remiss not to mention the online storage revolution. Backing up files to the cloud (which basically equates to server space on the internet) has become commonplace for many photographers.

○ **Cloud Advantages**: It negates the risk of losing photos through hardware failure, many companies offer a certain amount of free storage and it makes your photographs available on any device rather than where they're physically stored.

○ **Cloud Disadvantages**: Be aware that any personal data stored in the cloud runs the slight risk of being hacked into, so be vigilant about who has access to your devices, don't share or write down your passwords and make sure they aren't easily guessable.

Dropbox

Dropbox is the most popular online storage portal. It can be downloaded for Mac and Windows computers, accessed on the web at Dropbox.com and through a mobile app compatible with a multitude of platforms. The result is your photos safely stored and available everywhere.

Above: Dropbox is a great alternative to an external hard drive.

Above: The Dropbox app will back up all your photos and videos, enabling you to view them from anywhere.

> **Free or Paid:** You get 2 GB of storage for free, which is enough to save your most cherished snaps, but for around £100/$100 a year you can get 1,000 GB of storage.

> **Access Anytime:** You can back up a photo taken on your phone, access it from your computer, make edits and save the new version back to Dropbox.

Hot Tip

You can ask the Dropbox app for iOS and Android to back up all of your photos from your smartphone automatically.

Above: With Dropbox, you can see the alternations you made to an image immediately on your phone.

iCloud, OneDrive and Google+

Apple, Microsoft and Google all have their own cloud storage platforms, each offering free storage and subscriptions, with pricing tiers depending on how much space you require. All three services can allow files to be accessed on the web or through multi-platform applications.

○ **iCloud:** If you use a Mac and an iPhone, you'd be wise to go with iCloud, as it is ubiquitous across the platform.

○ **OneDrive:** If you use Windows products, OneDrive is your friend.

Above: Microsoft's OneDrive (formerly know as SkyDrive) enables you to access your photos from any of your devices.

○ **Google+:** Google+ Photos is a great tool, as it automatically backs up photos taken using those phones and tablets (iOS and Android), picks out the best ones and has great algorithms for automatically enhancing photos to present them in their best light.

EDITING YOUR PHOTOS

GETTING TO GRIPS WITH IMAGE EDITING

Image editing is great fun and can be very simple to do, so don't let yourself be put off by the array of jargon, tools, palettes and commands. This chapter will guide you through the basics of how to get the most from your digital photographs by using image-editing software on your home computer or on your mobile device.

WHAT DO YOU WANT TO DO?

Once you have taken your picture and transferred it to a safe home on your computer, you may be ready to print or share it on the internet or social media. However, you may wish to improve or enhance your photograph. You might not have held the camera straight and the horizon is slanted, or your subject may have red eye. Whatever your problems are, your image-editing software will help you to correct them with only a few clicks of the mouse.

Left: It is well worth investing in editing software, such as Adobe Photoshop Elements.

SOFTWARE PACKAGES

There are a great many editing software packages available on the market today. As we discussed in the last chapter, some simple, cut-down versions like Windows Photo Gallery and iPhoto are bundled with your PC or Mac. They can be a good starting point for your basic editing, and many of the simple techniques you would like to use can generally be achieved with most of these packages.

Pro-Standard Software

But if you are serious about creating quality and controlled results, it may be worth investing in a home package, such as Adobe Photoshop Elements or Paint Shop Pro. These home-editing programs offer more sophisticated functions and tools with a complete photo-management system. In this section we'll be focusing more on editing using Photoshop.

COMPUTER SET UP

Before you buy your software, it is a good idea to check out your computer's RAM and hard drive space. The latest version of Adobe Photoshop Elements 12 requires 2 GB of RAM and a whopping 4 GB of hard-drive space in order to install the software (plus more to assist during the installation), a 1024 x 768 screen resolution, a 16-bit video card and a processing speed of at least 1.6 GHz on Windows. You'll also need an internet connection to activate the software.

Right: Use image-editing software to correct basic errors, such as straightening a crooked horizon.

BUYING AND INSTALLING?

Back in the olden days, you'd have needed to buy a disc in order to install Photoshop on your PC or Mac. That's still the case for some users. You can pick up a copy from your local computing store and install it by placing the disc into your drive and following the instructions. However, you can also download the software directly from Adobe.com (or other portals), paying using your credit card. In both cases, you'll be asked to enter an activation code supplied with the purchase in order to start using the software.

Hot Tip

If you don't want to fork out for Photoshop or just want to see what you can expect, you can try Photoshop Elements in your web browser at www.photoshop.com/tools.

Above: Web-based Pixlr is a fantastic free tool to use to edit your photos.

OTHER SOFTWARE

This isn't just a Photoshop world. Although Adobe's trio of software (Photoshop, Elements and Lightroom) dominate the market, there are other players in the game. Corel and Cyberlink produce excellent, fully-featured editing programs while specialist raw processing applications such as DxO Optics Pro and Capture One remain popular with enthusiasts and professionals. There are also free options like GIMP, Picasa and the web-based Pixlr.

AFTER INSTALLATION

You should also spend some time assessing your work place. It is important to try to keep the monitor facing away from direct window light because the reflections may distract you. Place your computer in an internal corner with the monitor facing the wall, and try not to have an overhead light casting shadows across the screen. Any unwanted extra light can hinder you in achieving a consistent and accurate result. Make sure you have enough desk space to move your mouse freely and that you have full access to your keyboard for any shortcuts.

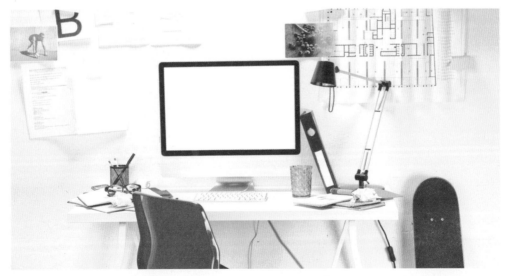

Above: Make sure your computer is set up correctly and placed in a suitable position before you start.

WHAT IS IMAGE EDITING?

Image editing is altering the appearance of the picture from its original state – this can mean anything from small adjustments that are almost unnoticeable to extreme enhancements that dramatically change the entire image.

EDITING SKILLS

Most of the skills described over the next few pages used to be achieved in a traditional darkroom, but now you will discover how digital manipulation can be done on your computer. By using one of the most popular and powerful home-editing software packages, Adobe Photoshop Elements, you will learn how to use tools effectively and apply commands correctly. You will learn to crop creatively, correct colours and tone and remove unwanted details. These techniques will help you to maximize the potential of your images.

Editing Using a Smartphone or Tablet

If you don't have access to a computer, or would like to learn how to edit your image on a smartphone or tablet, then *see* pages 170–173.

THE BASICS

A digital image is made up from thousands of small squares of colour called pixels. The more pixels an image has, the higher the resolution of the image. When you edit an image on a computer, you are altering these squares of colour by changing their colour or brightness. You can copy and paste them, move them around or even delete them entirely.

Hot Tip

If you use the zoom tool, you can enlarge your image enough to be able to see the squares.

Above: Cropping an image isolates a smaller image area and deletes the remaining pixels.

○ **Invisible pixels**: Generally, you won't see pixels as separate squares because they are too small.

○ **Screen resolution**: If an image onscreen is at 100 per cent magnification, then the pixels displayed will be grouped together 72 pixels per inch (ppi) by 72 per inch. This is called screen resolution and is the default resolution for most digital cameras (some pro models will save at a printing resolution of between 200 and 300 ppi).

○ **Image size**: The more megapixels your camera has, the bigger the physical size of the image will be, but its native resolution will stay at 72 ppi unless you change it. A 5-MP image may be made up of 2,592 pixels horizontally by 1,944 pixels vertically, and as its physical size would be 2,592/72 = 36 in (91 cm) by 1,944/72 = 27 in (69 cm) it will not fit on your screen all at once.

FINAL DESTINATION

It is a good idea to decide the final output for your image. If you try to work on a low-resolution image, e.g. a 4 x 7 in image at 72 ppi, you will find that the pixels are quite noticeable, not only on screen but in the printed version. The more pixels your image has per square inch, the easier it will be to work with.

Hot Tip

Resizing the image on your computer can compress more pixels into the inch.

If you want to print your images from a home printer, then you must have enough pixels contained in your image to give you at least the minimum satisfactory quality. For home printers, this is about 150 ppi. You can always size the image down if you want to send it by email, but it is rarely worthwhile to size it up for printing if it is not correct to start with.

Above: Image editing can improve the appearance of your photographs.

TOOLS & PALETTES

In image-editing software, most of the functions are displayed in little windows called floating palettes. They are movable, so they can be placed anywhere on your screen for ease of use. Everything you need to perform your chosen edit can be found on these palettes.

PALETTES

The first thing you will notice after launching your software is the tool bar palette on the left-hand side of your screen, the image menu bar along the top and the various palettes running down the right-hand side. This is called the workspace and you can customize it to suit your requirements. You can close palettes which you are not using, and then reopen them using the Image menu > Window or the tool bar.

Functions and Commands

Various functions and commands can be performed from a palette. One of the most popular is the Layers palette – this can build up new parts of an image, one on top of the other. Special effects can be added to an image from the Style palette, and technical help can be reached with the Help palette.

The Toolbar

The most important palette is the toolbar, which generally stays open at all times. This group of tools is used directly on the surface of the image and can be accessed quickly by using keystrokes.

Above: The palette on the left-hand side of the screen is invaluable.

- **Zoom Tool:** This looks like a magnifying glass, and is one of the most useful tools. You can use this to enlarge or decrease the size at which the image is displayed. If you click, hold the mouse down and drag across the image, you will notice a dotted

outline appear – this is called a marquee. This dotted line tells the computer how much of the image to enlarge. When you have enlarged your image, you can navigate around by using the hand tool. Click and drag the hand tool to move the image around the screen.

Above: The effects on the right-hand side can enhance your photos.

Selections

The selection tools have small black triangles on their icons. If you click and hold down the mouse on these icons, a small fly-out palette will pop up, offering you further options for that particular tool. The selection tools isolate areas of your image that you wish to either work on or exclude.

Cropping and Text

The Crop tool is accessed from the toolbar and can cut your image, removing parts that you don't need (*see* pages 166–167 for more on cropping). The Text tool can add words on to your image, that can be resized and coloured.

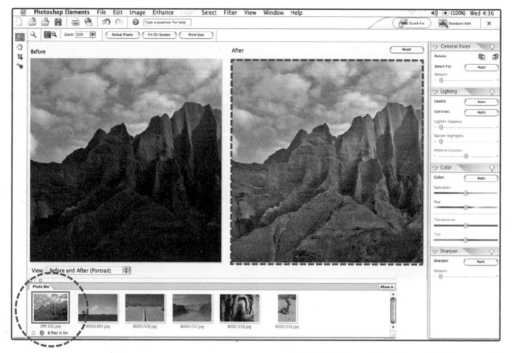

Above: Editing your photo will show definite improvement.

Painting Tools

These tools are more for specialist enhancements that may require drawing or painting. Mainly used by designers on illustrations, these artistic tools are used sparingly by photographers because of their obvious effect.

Enhancement Tools

These are the photographer's favourites and are specifically designed for directly affecting the surface of an image. These tools can sharpen or blur specific areas or lighten or darken others. The Clone Stamp tool replicates parts of the same image area, which is essential if you want to get rid of dust, scratches, or even unwanted telegraph poles (*see* pages 164–165 for more on using the Clone Stamp tool).

REMOVING RED EYE

This is probably one of the most common faults found with flash photography and can seem to ruin an otherwise great picture. With the help of your computer and software, you can easily correct this, but you should also learn how to avoid it altogether.

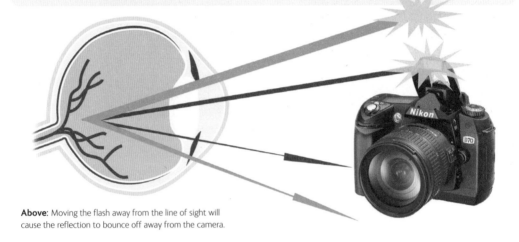

Above: Moving the flash away from the line of sight will cause the reflection to bounce off away from the camera.

CAUSES OF RED EYE

In typical red-eye conditions, the ambient light is dim and because of that, the pupil of the human eye will be fully dilated to allow in as much light as possible. The interior surface of the human eye is covered with blood vessels and these cause the red colour when the camera flash enters the eye, bouncing off the back and straight into the camera lens.

AVOIDING RED EYE

The way to avoid this is to not use the flash in the line of sight of your subject. For instance, if your camera has a hot shoe, use a separate flashgun with a tilting head. This way, you can bounce the

light from the flash off the ceiling or walls. Or more easily, set your camera to auto red eye. This will send a burst of light from your camera before the main flash and force the pupils to close down before finally taking the picture. This auto function doesn't always work to perfection and you can still end up with unnatural results.

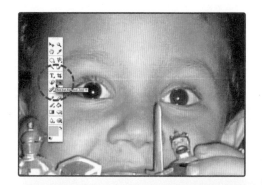

Hot Tip

The only way to correct red eye completely is with your computer. Don't worry, just use your editing software to clean it up.

CORRECTING RED EYE

Nearly all image-editing software packages give you the tools to remove this annoying fault. Most of them will give you a simple one-click tool designed to detect the flaw and, as much as possible, eliminate it from your photos. Just select the red eye removal tool from the toolbox and click, holding the mouse down, and drag a marquee over the offending eye and the redness will simply disappear.

You can adjust the size of the pupil (brush size) and the darkening strength by moving the sliders between 0 per cent and 100 per cent. You do need to be subtle when using this tool.

Above: To remove red eye from your photo, select the red eye removal tool from the toolbox and drag a marquee over the eye(s).

REMOVING UNWANTED DETAILS

It is very frustrating to find that your composition has been ruined by unwanted elements, such as telegraph poles and wires or people walking through your shot. All these can be removed with the use of the Clone Stamp tool.

HOW CLONING WORKS

The Clone Stamp tool works by copying neighbouring pixels and laying them over the top of the area you wish to erase. As this is a brush-based tool, it works best when you adjust the brush size continually throughout to suit the area. For fine details, it is advisable to keep the brush as small as possible to avoid obvious repetition of pixels. This is a powerful tool and needs plenty of practice and patience, but when mastered it can be one of the most effective tools at your disposal.

Above: This image is fine except for the telegraph pole. It can easily be removed with the Close Stamp tool.

How To Use Cloning

Take a good look at your image, decide on exactly what needs to be erased and where best to copy the new pixels from. Remember that you are replicating existing areas of your image so be aware that it should match as best as you can or it will look obvious. This is what you should do:

1. Use the zoom tool to enlarge the working area.

2. Next, select the Clone Stamp tool from the toolbar. The tool is displayed on-screen as either a cross, to pinpoint

the area you are working on, or a circle if you press the caps key on your keyboard, to illustrate the size of the brush.

3. Choose a suitable brush size from the image menu bar by dragging the size slider up or down. You can also select how soft the edge of the brush is from the options area.

4. Move the Clone Stamp tool over the part of the image you want to copy from. Hold down the control key (option key for Mac) on your keyboard and click on the image. By doing this, you are defining exactly where to copy to.

5. Either dab or stroke over the area you want to remove. As you move over the image, you will notice another cross following you. This second cross lets you know exactly from where the new pixels are being picked up. So you can check if you are going too far over the image, as the second cross will show you if you are about to pick up unwanted pixels.

Remember that if you do make a mistake, choose Edit > Undo Clone Stamp to undo the last action.

Above: Choose a suitable brush from the image menu bar.

Hot Tip

The Clone Stamp tool is indispensable when scanning in your prints as it can remove dust and scratches and repair tears and rips.

Above: Select a brush, choose where to copy from and start erasing.

BASIC ENHANCEMENTS: CROP & ROTATE

Every photographer – from the most experienced to the novice – can improve their photographs with simple cropping and rotating.

CROPPING

The majority of image-editing programs – however basic – include a Crop tool. It is very easy to use and can make a vast difference to your image. To crop is to retain only a section of an image – a crop can be large or small, depending on the effect you want to create.

Why Crop?

On occasion you may want to remove a section or object from your photograph that is spoiling the overall composition, for example, a person who has inadvertently walked into shot. Although every image-editing program is slightly different, this is how to crop your image:

Above: Cropping out irrelevant parts of a photo helps to keep the focus on the main subject.

1. Drag the Crop tool over the section of the photo you want to retain and a virtual box will appear over the photo.

2. You can then adjust the four sides of the box to fit the area you want to crop, leaving anything you want to remove outside, before finally activating the crop.

Improve Your Image

The Crop tool is a good way of improving a photograph and your composition, enabling you to experiment with different compositions and to see if the overall photo would have been improved if you had left some aspects out, or zoomed in more closely on a certain area. It is also useful as not all digital cameras show 100 per cent of the image area on their LCD screens or in their viewfinders.

○ **Beware!:** It is worth remembering that every time you crop an image, the file gets smaller, as you are literally throwing away image information. This may well affect the maximum size of your prints.

ROTATING

The Rotate tool is a very useful feature. We have all seen photographs blighted by horizons that are not quite horizontal or pictures of people who seem to be veering slightly to one side. There are several ways of rotating an image – in Photoshop, you can specify the number of degrees and direction (clockwise and counterclockwise) or rotate in increments of 90 degrees.

The cropping and rotating tools work together – every time you rotate an image, you will need to crop it in order to retain its rectangular format; very often, you will not be able to see which area of the picture needs cropping until you have performed the rotation.

Above: You may decide to rotate your image to straighten out a subject.

Above: You will need to choose an angle at which to rotate your image.

BASIC ENHANCEMENTS: COLOUR, BRIGHTNESS & CONTRAST

There are many reasons why a photograph may not look right – perhaps the day was particularly dull and overcast, or perhaps the camera settings were incorrect.

AUTO/MANUAL ADJUSTMENT

Photoshop Elements and Paint Shop Pro have a variety of tools to correct these problems, either automatically, where the program analyses the image and makes a change, or manually, where you control the adjustment. If you are new to digital photography, you can try automatic commands.

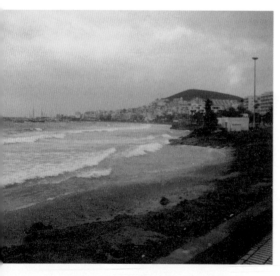

Above: Overcast weather can produce a dull shot.

BRIGHTNESS AND CONTRAST

Increasing the brightness and adjusting the contrast between the dark and light tones can make a huge difference to a dull image. In Photoshop, make adjustments by dragging sliders left down to minus 100 (to darken) or right up to plus 100 (to lighten) an image. Photoshop Elements and Paint Shop Pro both feature a tool that analyses the photo before adjusting the contrast for you.

How It Works

In Photoshop, the Auto Contrast tool is an automatic feature that works by finding the lightest

and darkest point of an image and then
distributing all the remaining pixels' tones between
those two points on the tonal range. In Paint Shop
Pro, the Automatic Contrast Enhancement offers
slightly more flexibility, because you can adjust
the bias/brightness (lighter, neutral and darker,)
the strength of the adjustment (normal or mild)
and the appearance (flat, neutral and bold).

Hot Tip

The auto tools will serve you well initially, but as you become more experienced, you can begin to take more control and make adjustments manually.

LEVELS

The Levels command offers
a greater degree of control
than the Auto Contrast tool.
It is able to do this by
changing the tonal range of
your photograph. It is
displayed as a histogram (a
vertical bar chart with
hundreds of fine bars): the
black lines represent the
distribution of highlights, mid-
tones and shadows across the

Above: Adjust highlights, mid-tones and shadows.

image. Make adjustments to the entire picture or the individual red, green and blue channels by
dragging the black (shadow), grey (mid-tones) and white (highlights) sliders at the bottom.

How It Works

Novices may find it useful to start using the Automatic Levels command found in Photoshop
– this tool works by finding the lightest and darkest pixels in each colour channel, converting
them to white and black and redistributing the remaining pixels between the two.

EDITING ON SMARTPHONES AND TABLETS

In the previous chapter, we discussed how it is now possible for photographers to live without a computer. Part of that equation is the growth of more powerful editing tools for smartphones or tablets that allow you to perfect your images and share them with the world, without transferring them to a computer.

APPS

Free and paid apps exist that allow you to do most things you would on your computer. Part of the reason for the growing popularity of cameras based on the Android operating system is the number of in-camera editing tools that are available to download.

POPULAR EDITING TOOLS

There are literally thousands of editing tools that can be downloaded cheaply and easily for your mobile devices. Android, iOS and Windows Phone devices all have built-in tools for perfecting photos. For example, the iPhone's Photos app allows users to rotate, enhance, add filters, remove red eye and crop. If you want more than that, try the following:

Left: If you want to have more editing tools available on your phone, you can now get a Photoshop app.

Adobe Photoshop Touch

The mobile version of the market leading imaging software brings in a smorgasbord of powerful features from the desktop software, including layers, brush tools, precise tone and colour adjustments. It's only £2.99/$4.99.

Below: Add fun effects or overlays to your photos with the Pixlr Express app.

Above: You can add text and graphics to your photos using Phonto.

Adobe Photoshop Express

For the basics, this pared-down version of Photoshop is great for quick fixes, edits and crops.

Pixlr Express

The mobile version of the popular web-based image-editing software offers neat tools like Focal Blur and Colour Splash, making it easy to get creative with your mobile snaps.

Phonto

Add attractive text graphics to your photos. There are more than 200 fonts available with adjustable size, colour, shadow, direction and line spacing.

Instagram

Useful if you plan on sharing via the photo-centric social network, the Instagram app, with its easy-to-use filters and cropping tools, set the standard for anyone-can-do-it editing on mobile devices.

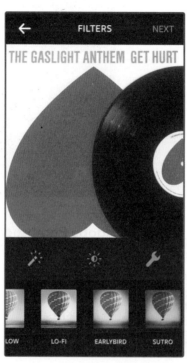
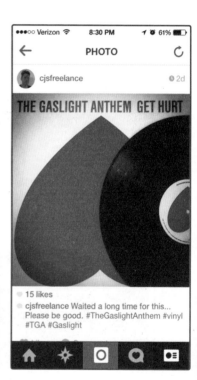

Above: Instagram is a great app to enhance your photos by cropping and choosing filters.

PicsArt

You can use this app to create amazing collages from your photo albums, but there's much more to it than that. PicsArt is a fully featured editing tool, with tons of neat effects and the ability to import your Instagram photos.

ADVANTAGES OF EDITING ON A MOBILE

○ **Speed**: This is the key advantage. The photos are already sitting there on your device, so there is no need to spend time transferring them to the computer. The photos can immediately be retouched the moment they're taken.

○ **Intuitive apps**: The apps used for editing are designed to be user-friendly, intuitive and simple to use, meaning there's no need to learn complex editing software. Improvements are often made with one tap of a button like 'Auto Enhance'.

○ **Easy to share**: You can also easily make picture collages from a day's activity before sharing online. Sometimes, the shooting to editing to posting process can be done in under a minute. The wonders of modern technology, eh?

> ### Hot Tip
>
> **Many apps that facilitate photo sharing also have built-in editors. The likes of Facebook, Flickr, Instagram, Twitter and more all allow you to fine-tune before posting.**

DISADVANTAGES OF EDITING ON A MOBILE

○ **Poor control**: While there are plentiful options for editing your photos on mobile devices, it is difficult to maintain as much control when performing fine, detailed edits. A touchscreen is harder to operate than a mouse and keyboard combination when, for example, attempting to crop images, alter image size, remove elements from photos or touch them up.

○ **Screen size**: Naturally, editing on a 4–5-in (10–12-cm) screen rather than one of 20-in (50-cm) plus makes it more difficult to see the finer details.

SHARING YOUR PHOTOS

SHARING YOUR PICTURES

One of the most enjoyable elements of photography is sharing your pictures, either to relive memories or to share an event with someone who missed it. Digital photography makes sharing pictures easy, because pictures are stored as computer files and you can attach them to an email or upload them to social media sites like Facebook, Twitter and Instagram, or online photo galleries like Flickr.

Above: Start your story at the beginning.

SHARING PHOTOS AT HOME

Before we talk about sharing your snaps with the wider world, let's start a little closer to home. There are several ways you can view photos in the home setting without busting out an old-style slide carousel and projector screen.

Creating a Slideshow

Gathering around a laptop or computer can be a great way to share photos with your loved ones. Undoubtedly, the photo management program you're using will have a slideshow tool. All you need to do is select (or create) an album you wish to showcase.

○ **Using iPhoto**: A 'play' button for Slideshow sits at the foot of the window when viewing events or albums. Hitting play will allow you to choose themes, music and settings, such as the dwell time on each photo and how to transition from one to the next and even add captions for each photo. You can also manually control the transitions such as fades and wipes, pan and zoom effects or photo frames.

○ **Using Photo Gallery**: In Photo Gallery for Windows simply click the Home tab and select Slideshow for similar options.

Burn your Slideshow to Disc

If you have a HD television at home, it's the perfect canvas to show off your photos in all their glory. Creating a CD/DVD slideshow from your computer is one of the easiest ways to do this. CD/DVD slideshows are more personal; you can choose exactly which photographs will appear and for how long, create captions and add fun sound effects. Operation is very straightforward – put the disc into the DVD drive and hit play.

Above: Create simple but effective slideshows in Windows Photo Gallery.

Hot Tip

Mac users. If you have an Apple TV box you could send the iPhoto slideshow directly to the television using AirPlay Mirroring.

Above: You can export your slideshow to view it on a variety of devices.

○ **Export slideshows:** Some photo management tools, like iPhoto, allow you to export slideshows you've created as video files that can be easily transferred to disc.

Hot Tip

It makes sense to ensure the order is logical; if the subject of your slideshow is a summer holiday, avoid beginning with a photograph taken at night or towards the end of the holiday.

○ **PhotoStage Slideshow:** Other specialist tools like PhotoStage Slideshow can also take care of the task. They will require you to locate your photos and choose which you want to include in a slideshow and select transitions, sound effects and captions and loops to accompany your slideshow.

Connecting Your Device to the TV

Burning your slideshow to disc is just one method of getting it on the living room TV. You could also hook up

your desktop or laptop to the television via HDMI cable or video component cable. You can then mirror the screen using your computer's Display settings and by hitting play on the slideshow.

Using the Internet

The connected living room has become a huge trend in the last couple of years. Many televisions are internet-enabled, and there are plenty of devices, including Chromecast and Apple TV, that can bring connectivity to your set. As such, it has become easy simply to beam your pictures to the TV over Wi-Fi.

> **Hot Tip**
>
> Most cameras let you connect directly to the TV, either with a micro HDMI port or A/V out. You can move through photos using camera controls.

○ **Via Apple devices**: Apple's AirPlay technology allows you to mirror the screen of your iPhone, iPad or Mac via the £79/$99 Apple TV set-top box.

○ **Via Android devices**: If you're an Android phone or tablet owner, you can use the £30/$35 Google Chromecast HDMI dongle to 'Cast' your photos. From there, it's easy to swipe through your photos using the touchscreen of your device or your computer keyboard as a remote control.

Below: If you're an Android user, you can use the Google Chromecast dongle to view your photos on your TV.

SHARING PHOTOS VIA THE INTERNET

Perhaps the most tangible benefit of digital photography is the ability to share your photos with anyone in the world. Whether it's emailing your far-flung relatives the latest pictures of the kids, or simply posting a snap of the meal you're about to consume on Facebook, sharing online is just a couple of keystrokes or touchscreen taps away.

MAKE SURE YOU'RE CONNECTED!

To share photos via the internet, you must either be connected to a wired or Wi-Fi network or be using mobile data on a smartphone or tablet.

Above: Click on the paperclip icon to attach a photo in Gmail.

Sharing via Email

Email is one of the predominant forms of photo sharing, from computers, smartphones and tablets and even some cameras. If you're using your home broadband connection, it is extremely straightforward.

> # Hot Tip
> **Gmail users can send files up to 25 MB, which are hosted on the cloud-based Google Drive platform. This provides the recipient a link to download the file.**

1. Log into your email account (Gmail, Outlook, Yahoo Mail, etc.) and hit Compose or New to begin a message.

2. To attach a photo, simply click the paperclip icon and select the photo from the file browser. Depending on the size of your photos, you can send multiple photos per email, but for anything totalling over around 10 MB, you should probably split them into multiple emails.

Above: If using Outlook, drag a file on to the email to attach it.

Above: Apple's iMessages allows you to send photos to friends easily.

Above: You can share photos using Apple's iCloud service by touching the cloud icon.

3. After the files are attached, simply add the recipient's email address into the 'To:' field, add a subject in that field, and maybe some text to accompany the snaps and hit send.

Sending Personal Emails from Work?

With the majority of work-based communications taking place via email, it is inevitable that some people will email photographs from work. Whether this is allowed or not depends on the policy of the individual employer, but many actively discourage it, so it is worth checking your contract before sending personal photographs this way.

Sharing via Instant Messaging

As smartphone and tablet photography becomes more prominent, lots of people are using instant messaging services to share photos from anywhere in the world to anyone in the world. Apps like WhatsApp, Facebook Messenger, Apple iMessage and Skype allow users to simply attach a photo to a message that'll be delivered straight to the recipient's device. These individual mobile apps (some are available on desktop too) mostly have a camera icon next to the compose field, which will allow you to select a photo from the gallery or camera roll, or even take one before attaching. If you've opted for a compact camera running on the Android OS, you will also have these applications available to you.

Sharing Via the Cloud

As we mentioned in Chapter 4, cloud services are a great way to keep your photos safe and accessible online. You can also use apps like Dropbox to share a large volume of photos. For example, if you've taken a batch of photos of someone's wedding, rather than sending the photos a bit at a time by email, you can upload the whole batch to Dropbox and simply share a link privately to the happily married couple so they can download at their convenience.

SHARING WITH THE WIDER WORLD

While some photos are intended for an audience of a few, others deserve to be shared with the world. Thankfully, the World Wide Web is pretty good at facilitating that demand.

SHARING VIA SOCIAL MEDIA

Social media sites like Facebook and Twitter infiltrate most aspects of our lives these days. We check in at restaurants, we post funny YouTube clips, update statuses with our current moods, but mostly we post photos. Lots and lots of photos.

Sharing via Facebook

In late 2014, it was estimated that 350 million photos were being uploaded to Facebook every single day. In total, the site features a quarter of a trillion snaps. That's an average of 217 photos per active user, making it the most popular destination on the web. It's easy to upload photos from your phone or tablet via the free, dedicated Facebook app:

1. Select the camera icon and choose the photos from your album. If you're using your computer, you can just browse to Facebook.com and select Add Photos/Video and choose the file(s) from wherever they're stored on your computer.

2. Having selected the photo(s), you can add descriptions, tag a location, decide who can view the photo, tag your friends who are also using Facebook.

Above: To upload a photo to Facebook from your phone, touch the camera icon and select a photo.

Hot Tip

Want to increase the potential viewership of your photo? Add a hashtag. For example, the hashtag #tbt to accompany an old picture means Throwback Thursday.

3. Once posted, it'll appear on your profile page, within your online albums and in the news feeds of those you've chosen to share with. Your friends will be able to like, comment and if you allow it, share the photo with others.

Sharing via Twitter

Twitter is less of a destination for sharing albums of your holiday snaps, but more for posting a one-off snap to accompany a few characters of text. Something interesting you observe in your town, perhaps? You can easily add photos to

Above: Sharing a photo on Twitter will put it on your followers' timelines.

Twitter in much the same way as you can with Facebook. People can reply to the post and share it with their own followers by 'Retweeting.'

Sharing via Instagram

The mobile-only sharing app is the perfect example of how your mobile device can be a one-stop shop for photography. You can take a photo with the app, crop it perfectly, straighten, adjust contrast, add cool effects like Tilt Shift (which defocuses areas of the photos) and then add one of many Filters, which adjust colours, contrast and add effects to give your snaps the appearance they were taken with a different lens. All that can be done in just a few seconds; next, simply add a caption – and a hashtag if you choose – and share the photo with your followers.

PRIVACY AND SECURITY

It's important to realize that when you share a photo on social media, there's only so much privacy you can expect. If you value your privacy and, for example, don't want photos of your kids to be seen by all of your Facebook followers, perhaps an instant message or an email would be a better option. Instagram also has a direct messaging option if you'd rather not share with anyone. The likes of Facebook, Twitter and Instagram allow you to keep your accounts completely private too, meaning the only people who can see your content are those you agree to be friends with or be followed by.

Above: Instagram allows you to share your photo on all of your social media platforms at the same time; just select the ones you would like it to appear on.

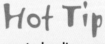

Hot Tip

Photos posted online can easily be copied, saved and shared elsewhere, even if you believe you've kept the sharing circle relatively closed-off.

Facebook Privacy Settings

On Facebook, there are several levels of privacy settings when you share a photo:

- **Public**: This means anyone can see it.

- **Friends**: This means it's visible to your friends.

- **Only Me**: This will keep the snap visible to you only.

- **Custom**: This allows you to pick specific friends and also the opportunity to share with Groups you may be part of.

Above: Facebook allows you to choose who will see your photos.

HOW TO USE AN ONLINE SHARING WEBSITE

Social media is great for sharing with friends, family and the world at large, but there are many online photography websites where you can display your images for free and meet like-minded photographers.

ONLINE SHOWCASES

Websites like Flickr and 500px are great places for serious photographers to showcase their work. Those sites permit photo uploads at a high resolution, allowing them to be displayed at

Above: Flickr is a great place to show off your work to other photographers.

their best, while social networks will generally compress photos, affecting their quality.
Meanwhile, websites like Photobox.com are great places for photographers to upload pictures
into a gallery and even print off those photos and have them delivered to you. It's also easy to
share those galleries and images with others online.

Online Comments

Many photo-sharing websites include message boards, which you can access by registering, so
that you can comment on other people's images as well as inviting criticism of your own and
getting shooting tips – a great way of improving your photography and generating healthy
debate. Many people enjoy being part of an online community and these sites are well known
to photography fans, often with thousands of members.

Above: Flickr allows you to create albums.

Signing Up

To join an online sharing
website, you will need to
sign up. This involves
choosing a username and
password and entering
basic information including
your email address. Most
of the pro-themed sites
will have fewer limits on file
size, so you'll be able to
upload your photos in all
of their hi-res glory.

Legal Issues

As an amateur photographer, you own the copyright of every picture you take, but once
your pictures go on to the internet, they are in the public domain and could be copied by
other photographers.

- **Limit Your Audience**: As we mentioned earlier in the chapter, you can limit the audience, but this is no guarantee.

- **Add a Watermark**: To retain your intellectual property, you can add a watermark (establishing that the photo is your copyright) to your image in Photoshop, which is embedded into the file and cannot be removed. It is also worth adding a caption containing your name and the year when uploading the photograph.

Above: 500 px is a place to improve your craft and show off your best shots.

Above: PhotoBox lets you upload your photos and buy prints, calendars, mugs and other gifts with them on.

- **Children**: Be aware of issues regarding content. Whether it is right or wrong to upload photographs of children has provoked heated debate, and while the majority of photographs are innocent, if you want to upload images of a child's birthday party to your website, it is best to obtain permission from the parents first.

- **No-go Areas**: Other potentially problematic subjects include airport check-in desks, army bases and banks. Sexism, racism and political discontent are also contentious issues.

CREATE YOUR OWN PHOTOGRAPHY WEBSITE

A web gallery or personal blog is a very effective way to share your digital photographs, and is often made up of thumbnails or full-screen pictures that others can click on and view.

BE SEEN!

Like a community site such as Flickr, your personal website can be viewed from anywhere in the world and by anyone, making it a great way of sharing images. It's also a perfect way for photographers to create an online portfolio, complete with their favourite shots, contact details, a biography and a means for viewers to enquire about buying photos or acquiring services.

Above: It takes no more than 30 seconds to join Tumblr.

OPTIONS FOR YOUR WEBSITE

One of the easiest ways to create your personal photography site is to use an existing blogging tool like Tumblr or WordPress. These free hosting sites allow you to choose a name for your blog, heavily customize the look and feel of your page to suit your

photography style, plus they feature simple content management systems for uploading and captioning photos. Just go to Tumblr.com or WordPress.com to get started. The sites are very user-friendly and you'll be up and running in no time.

CHOOSING A DOMAIN NAME

Blogging tools allow you to choose a name for your blog hosted on their domain. So, for example, your unique web address would be something like blogname.tumblr.com. However, if you want to go out on your own, you can buy a website domain name and link it to a publishing platform (such as WordPress.com), allowing you to customize design and upload content. Portals like GoDaddy.com let you know what's available and allow users to buy the domains for an annual fee.

Above: Buying a domain name from GoDaddy.com will allow you to choose your domain name from those available.

FINDING A HOST

If your needs are basic, your best bet is a free WordPress.com blog, which allows you plenty of flexibility to import your own domain name and also enables you to customize the site's design to a certain degree. However, for a little more control over every aspect of your website, you might wish to find a web hosting company. Some offer free tiers, while others will charge a monthly fee.

Hot Tip

Before choosing a web host, check up on which providers best suit your needs and the support they offer customers.

PRINTING YOUR PICTURES

Digital photography and online sharing is all the rage these days, so much so that it's easy to forget that printing photos or having them printed is one of the great joys of sharing photos.

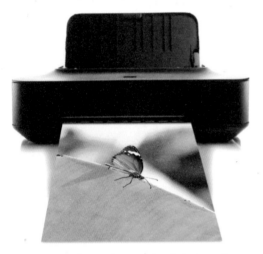

Above: Print out your photos so that you can later display them in frames.:

PRINTING AT HOME

In the olden days of film photography, most consumers would hand the roll of film to a chemist and return an hour later to collect their prints. Digital photography is different – you can choose exactly what to print and you have the option to print it yourself.

WHY PRINT AT HOME?

A digital photograph is a chain of events that begins when you look at the scene, choose the right camera settings, press the shutter and preview the shot in the viewfinder. Then you take part in the post-production process by uploading your picture on to the computer and making tonal adjustments so that it looks exactly the way you want. The final link in the chain is either sharing via the internet or printing.

Left: A photo printer is the final step in having complete control over your photos.

Convenience

One of the major advantages of printing at home is convenience – you can turn on your computer and start printing – and it can be very rewarding to print your own pictures.

GETTING TO GRIPS WITH YOUR PRINTER

Home printing may initially seem daunting: colour management, size and resolution are just some of the areas you need to understand; we look at these in detail on pages 194–196.

User-friendly Devices

Printer manufacturers are realizing that more people want to print at home and are producing user-friendly devices. Once you get used to your printer and understand how it works, you will be able to print quickly and – crucially – to control exactly what you print.

THE COST OF PRINTING

While the cost of ink and paper can be pricey and home printing cannot match some of the deals on the high street, it is increasingly affordable. The price of new printers is dropping – an adequate inkjet printer can cost less than £100/$150.

Above: Choose a printer that will produce high-quality images.

Above: It is crucial to buy the right ink for your printer.

Hot Tip

Many document printers are able to produce photo-quality prints by using different paper or ink.

HOW TO MAKE A PRINT: SIZING & RESOLUTION

Before you start printing, it is important to check that your camera is capable of producing good-quality prints at the size you desire. The number of pixels in your camera determines the size you can print – the greater the number of megapixels there are, the larger the prints you can produce.

QUALITY OVER QUANTITY

The key is quality – the lower the resolution, the fewer pixels per inch and the more chance there is of the space between the pixels becoming visible to the viewer. The minimum resolution you should print at is 200 pixels per inch (ppi), with some people recommending 300 ppi for photographic-quality prints.

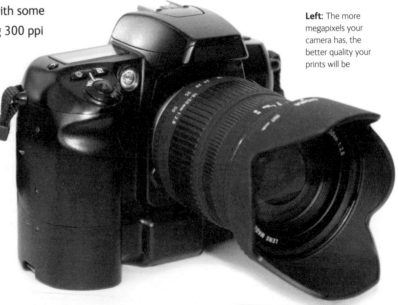

Left: The more megapixels your camera has, the better quality your prints will be

PRINT SIZES

Here are some approximate print sizes for typical digital cameras. These are not exact calculations as printers do not print

the image out as square pixels, rather they convert the image into one made up of round dots through a process known as dithering. A good inkjet printer may have a printing resolution (the number of dots used) of 2400 x 4800 dots per inch (dpi).

○ **200 ppi**: If you use an image resolution of 200 ppi the maximum image size a 2-MP camera is capable of producing for optimum quality is 20 x 15 cm (8 x 6 in), whereas a 9-MP camera can produce prints as large as 44 x 33 cm (17 x 13 in) at 200 ppi.

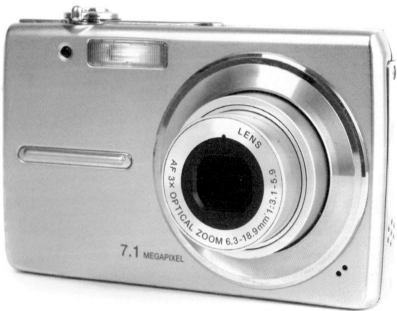

Above: A 7.1-MP compact camera is great for standard-sized photos.

○ **120 ppi**: It is possible to produce A4 prints from a 2-MP camera at a resolution of 120 ppi, but the quality may not be particularly high.

Changing the Image Size

You can change the image size and resolution in Photoshop through the Image Size options. Before you make any adjustments to the image size, make sure that Resampling is turned off, and check the Constrain Proportions box to make sure that you don't accidentally adjust the scope of the image.

1. Using either 'cm' or 'inches' (depending on your preference), enter the desired width you want to print in the Document Size box. You will see the Resolution change – if it falls under 200 ppi, the print size is too large and for good-quality prints it is advisable to enter a smaller print size.

Hot Tip

Be careful if you are resampling to create a larger image size, as the quality can be greatly reduced.

2. Once you are happy with your image size, tick the Resample Image box and enter your desired resolution. If you are reducing the size of the picture, you will see the Pixel Dimensions change and the image size decrease. This is because, by resampling, you are adjusting the pixel make-up of the entire image, and as you reduce the file size, pixels are deleted.

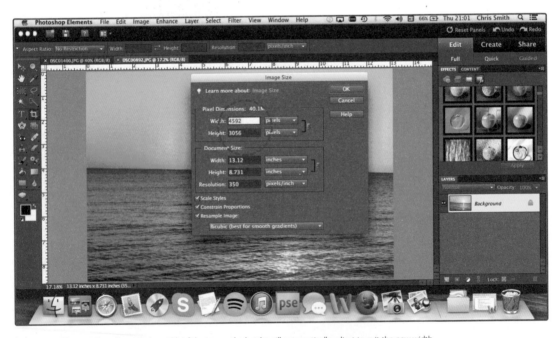

Above: When changing the width of the image, the height will automatically adjust to suit the new width.

UNDERSTANDING THE PRINT OPTIONS

The easiest way to check how your print looks on the page is to preview it. With this useful tool, you can see the position and size of your photo on the page before it is printed, ensuring you can make any necessary adjustments before you commit to print.

PRINT PREVIEW

In Photoshop, select Print from the main menu and your photo will be displayed as a preview on the print screen.

Page Orientation

Your preview will let you know if the page orientation is incorrect – if you print a landscape photograph in portrait format, you will lose half your image and waste paper. This is adjustable in most image editors through the page setup command, or in Photoshop by clicking the Page Setup button.

Above:
Always print using the correct paper orientation for your image.

Print Sizes

Printers can produce prints in a range of different sizes – 15 x 10 cm (6 x 4 in) and 18 x 13 cm (7 x 5 in) are fairly standard, but you can

Above: You should familiarize yourself with how to use your printer.

also print up to A4 and produce panoramas. Photoshop retains previous printer settings, so if you are printing out on a different paper size, ensure the Scale is set to 100 per cent, remembering to later select a new paper size before printing.

Hot Tip

If you want the print to fill the page, tick Scale to Fit Media in the print options.

Paper Orientation

Before you begin to print, check the paper is positioned correctly – you may need to refer to the manual to see whether it should be face up or face down. To the eye, gloss and matt sides of paper can look very similar and it is easy to print on the wrong side.

Above: The best way to ensure that you have chose the correct print options is to preview your image.

Ink Levels

Check the status of ink in your printer, otherwise your print may lack colour tones (a warning usually appears on the LCD screen of your printer). However, after the warning appears, you should be able to keep printing, depending on the model of printer.

TYPES OF MEDIA

It is important to choose the right paper for your prints so that you can show them at their best. It can be difficult knowing which to choose with so many different paper types and brands on the market, and the paper you choose will vary depending on what you are using your prints for.

Paper Surfaces

You need to consider the type of surface you want your paper to have, from matt to satin (which is slightly shinier), or semi- and high-gloss finishes. The majority of processing labs use gloss, although matt printing is often an option. The glossier the finish, the more reflective it is.

Above: The type of paper you choose can have a big impact on your photo.

Hot Tip

Bright colours benefit from shinier, glossy paper, while for more subtle photos, a flatter, matt surface is effective.

Above: Most photos benefit from being printed on glossy photo paper.

Paper Weight

The weight of the paper is important – the more grams per square meter (gsm), the heavier – and more expensive – the paper. For text documents, 80 gsm is suitable, while photographic prints need a minimum weight of 230 gsm.

Available Colours

Photo paper is not just white; it comes in a selection of shades – such as pearl and oyster – each of which produces different results. The whiter the paper, the brighter the colour results.

Matching Printers with Paper

Major printer manufacturers, such as Canon, HP and Epson, recommend printing on own-brand paper because the ink and paper are designed together to produce optimum results on the page. However the photo paper market is increasingly competitive so check what paper your printer is compatible with before investing.

Above: There is nothing better than having a personal postcard to remember where you have travelled to.

○ **Try Before You Buy**: If you are unsure about what paper to use, many paper manufacturers produce sample packs containing a selection of different paper types, which is an advisable investment.

Other Media

You can also print on to stickers, postcards and CD covers, as well as canvas or fine-art paper, but these can be expensive, so try to avoid wasting paper with errors, and always produce a test print.

GET IT DONE ELSEWHERE

If you don't have the time or inclination to print, or you do not want to spend money on a printer, you can send your photographs to a third party to print them.

USING A LAB

High-street printing is straightforward, although it varies from store to store. Self-service kiosks are becoming increasingly popular and are easy to use:

1. Insert your memory card into a slot or connect your device via USB or wirelessly via Bluetooth.

2. Simply select the photos you want to print and the desired size and quantity by pressing icons on the screen. It is a very simple process and you can always ask a shop assistant for help (or ask them to do it for you).

The price of printing on the high street changes all the time, with the supermarkets edging out photographic stores in terms of value, but both are cheaper than home printing.

Above: Kodak print kiosks allow you to insert your memory card and select your prints.

Hot Tip

In common with online photo labs, the more prints you buy, the cheaper the price per print tends to be.

Above: Third parties can put your images on mugs.

Above: Jessops can print your photos for you quickly and to a great standard.

UPLOADING TO ONLINE LABS

The advantage of buying online is that you can order prints at home and they will be delivered directly to you. Delivery times can range from a day to a week; most companies offer standard delivery, the price of which depends on what you have ordered. You will need to register at the website and provide your email addess for correspondence and your postal address for delivery.

○ **Good deals**: Print prices are generally lower online because the overheads of the online companies are low. Shop around to find the best deal, because many retailers offer introductory free prints for registering and more for referring a friend.

○ **JPEGs**: To save time before you upload your images, you should save your photographs as JPEGs (this is the commonly accepted file format, because TIFF files take too long to upload) and place them all into one folder.

○ **Simply upload**: Some sites require you to download software to upload photos, while others allow you to upload straight to the retailer's website.

○ **Order and go**: Ordering prints is designed to be easy and is usually a step-by-step process. You choose the number of prints, size and finish, and at the final stage, you enter your credit or debit card details. Confirmation is then sent to your email address.

Hot Tip

Some printing websites offer free storage for your pictures, enabling you to order more prints without having to upload images again.

SCANNING AT HOME

You can convert photographs and negatives into digital files using a scanner, perfect for bringing older photographs into the 21st century, allowing you to touch them up and share them with family and friends.

WHY INVEST IN A SCANNER?

The majority of households across the country will have boxes of photographs collected over the years, waiting for someone to sort them and put them in an album. A flood or a fire could destroy hundreds of pictures, representing precious memories. One way to avoid this is to invest in a scanner – a device that converts your prints or negatives to digital files through a process called digitizing. This process converts information about different light values from the picture or transparency into pixels on your computer.

Above: Don't let old photos be forgotten.

Right: A scanner and computer are all you need for a digital darkroom.

TYPES OF SCANNER

There are two types of scanner, and the device you need depends on what you intend to scan:

- **Film scanners**: These scan transparencies, including negatives and slides.

- **Flatbed scanners**: These scan photographs and sometimes transparencies (with an adaptor).

Hot Tip

You can also use scanners to restore black and white photographs, particularly those that have been damaged and scratched.

Once a photo or negative has been digitized, you can apply the same editing techniques that you would use on a digital photograph: correcting uneven horizons, repairing colour casts, cloning out unwanted elements and removing red eye.

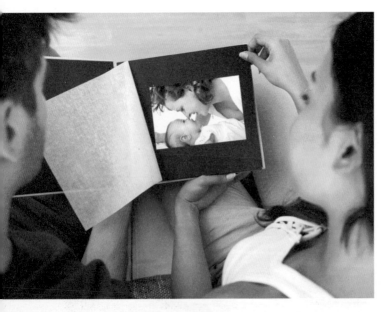

Once You Have Scanned

Scanning old photographs makes it easy to share your pictures, by attaching the file to an email or incorporating them into montages and photobooks for friends and relatives. Crucially, you can save the files on to a CD or portable storage device to create a back-up and preserve it for future generations.

Left: Photobooks should be kept for future generations to look back through.

PREPARING THE SCANNER

Flatbed scanners work by shining light on to the surface of the photo, where it is reflected and caught by the sensor (CCD, or Charge-Coupled Device). Before you begin to make a scan, turn the device on for a few minutes to allow it to warm up.

Care needs to be taken to ensure the photo is dust-free and that the glass plate is clean, otherwise particles of dirt may be visible in the scan.

Below: Flatbed scanners allow you to scan in images by placing them on the glass bed.

MAKING A SCAN

When you are ready to make your scan, here's what to do:

1. Open the plastic hood and position the photo on the glass plate. Make sure it is aligned carefully, or you may have to rotate the photo using your scanning software, which can lead to a reduction in picture quality. (Photographs are scanned on one side, which means it doesn't matter if you perform the scan with the lid open.)

Hot Tip

If you're adverse to all of that effort, there are scanning companies who will do this for you.

2. The easiest way to make a scan is to hit the Quick Scan button (located on the front of many new scanners) although for a greater degree of control you can perform the scan using the software on your computer. You will hear a whirring noise as a sensor positioned inside moves up and down making the scan.

3. The results will appear on your computer screen, which can then be exported to image editing software, fine-tuned and shared. The cycle is complete.

CAMERA ACCESSORIES & MAINTENANCE

LENSES

The quality of lens that you use on your digital camera will affect – and possibly limit – the quality of the image that your camera can produce. If you own a digital SLR (DSLR), you will be able to buy additional lenses and expand the range of your photography.

Above: This photo has been taken using a wide-angle lens.

SUPPLEMENTARY LENSES

Cameras with fixed (i.e. permanently attached) lenses can be made to be more flexible with the addition of supplementary lenses, but your camera needs to have a filter ring or a special adaptor in order to be able to take advantage of these.

There are two types of lens: fixed focal length and zooms. Fixed focal length lenses are covered on the following pages; we look at zoom lenses on pages 211–212.

FIXED FOCAL LENGTH LENSES

Focal length is a scientific measurement of the distance between two key points in the optical train of a lens. This measurement is meaningless when quoted alone, but when it

is used in conjunction with the size of the image area (in practical terms, the size of the sensor), it gives you information about how much a lens will magnify an image and also how much of a scene it can fit in.

It is usual to see two figures quoted: the actual focal length, and what focal length would be required to get the same image magnification if the sensor were the size of a 35-mm film frame. So a DSLR lens may have an actual focal length of 12 mm, but has a 35-mm equivalent of 18 mm. These equivalents are quoted so that you can compare different types of digital camera lens from different manufacturers.

Above: Wide-angle lenses literally give a wide angle of view.

TYPES OF FIXED FOCAL-LENGTH LENSES

Fixed focal-length lenses come in one of three main forms, with short, medium or long focal lengths.

Wide-angle Lens

The first of these is known as a wide-angle lens, as it gives you a wide angle of view (and consequently, a small image magnification).

Standard Lens

A medium focal length lens is often known as a standard lens (as this used to be the lens that came as standard with a new DSLR) and will have a focal length of about 50 mm.

Telephoto Lens

A telephoto is a higher magnification lens and as, the literal translation of its name (far light) implies, it enables you to take pictures of objects far away.

FIXED FOCAL LENGTH LENS ADVANTAGES

Fixed focal length lenses have several advantages:

- **Less Complex:** They are less complex to design and build than zoom lenses, and it is therefore cheaper to build a really good fixed focal-length lens than it is to build an equivalently good zoom lens.

- **Big Aperture:** The maximum aperture of the lens determines the maximum amount of light it will let through to the viewfinder and the sensor. A big (known as fast) aperture allows more light through and thus makes it easier to see through an optical viewfinder

Hot Tip

A big aperture allows faster maximum shutter speeds to be used, which is useful for any lens.

and check focus and composition, which is particularly useful with wide-angle lenses. It also allows you to blur backgrounds more easily, which is useful for telephoto lenses.

ZOOM LENSES

At one time, zoom lenses were an expensive curiosity. Now they are by far the most popular kind of lens found in photography – whether on compact digicams or on digital SLRs. The focal length of a zoom lens can be varied in order to aid composition. In theory, a zoom lens is one that does not require refocusing after its focal length has been changed, while a varifocal is one which you do need to refocus. In practice, whilst many zoom lenses do need refocusing, this job is taken care of by autofocus systems, so it may not be obvious which type of zoom lens you have.

Technical Information

Like fixed focal-length lenses, the focal length of zoom lenses determines their image magnification and angle of view.

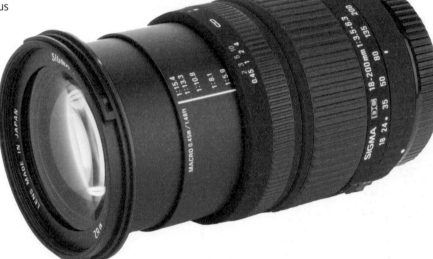

Above: Zoom lenses are a very popular accessory.

They are always shown as two figures: the minimum and the maximum focal length. For example, 28–70 mm describes a zoom with a minimum focal length of 28 mm and a maximum of 70 mm. This kind of lens is known either as a wide-angle zoom (as its minimum focal length is that of a - one) or a standard zoom, as its focal length range includes 50 mm.

Above: The first image shows Big Ben in the distance behind a statue.

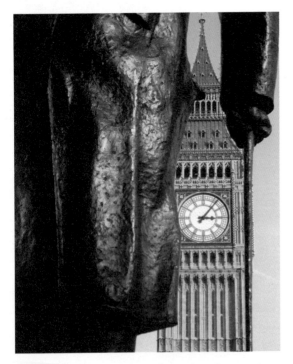

Above: This second image shows the difference a zoom lens can make.

You might also see this kind of lens described as a 3x zoom, as its maximum focal length divided by its minimum focal length is about three. A 35–42- mm lens would therefore be known as a 12x (420 divided by 35 = 12). This is known as a telezoom (as it includes telephoto lengths) or as a superzoom as its zoom ratio is over 6x.

Hot Tip

You are unlikely to find superzoom-style lenses as a digital SLR lens, as their sensors are bigger and this would be a huge piece of glass to carry around.

Own a Range of Lenses

Like fixed focal-length lenses, different zoom types are useful for different kinds of photography. It is therefore useful to have a range of different focal lengths available. The less ambitious the zoom range, the more likely it is to make a good lens, but bear in mind that you will have to buy more lenses to cover the same focal-length range as a superzoom.

CAMERA ACCESSORIES

A camera, plentiful memory cards and a choice of lenses is enough to get any photographer started, but there are plenty of neat tools and accessories any serious photographer should have at their disposal.

Strap

If you've spent a lot of money on a camera, the last thing you need is a cheap strap (like those bundled with the camera!) that will fall apart and send your camera crashing to the ground. Invest in a sturdy shoulder strap that will allow you to keep your hands free while taking photos. Some straps feature pockets for memory cards, batteries and the like, while others feature padding for long sessions.

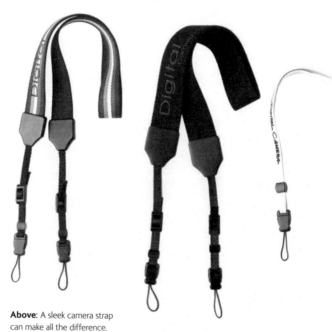

Above: A sleek camera strap can make all the difference.

Camera Bag

If you're rocking a pocket-sized compact camera, this is less of an issue, but for DSLR users, it's important to have a

Hot Tip

With straps, try before you buy and put security over style.

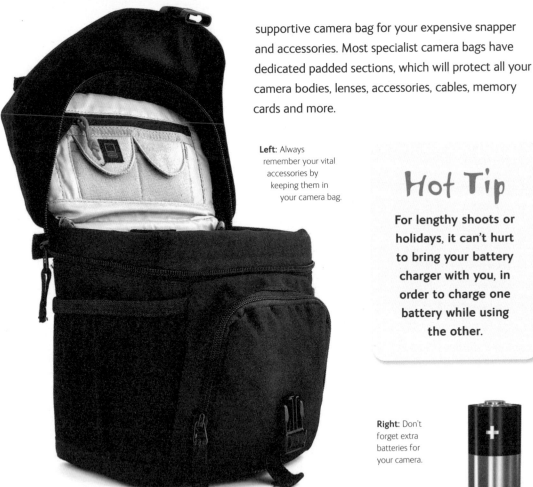

supportive camera bag for your expensive snapper and accessories. Most specialist camera bags have dedicated padded sections, which will protect all your camera bodies, lenses, accessories, cables, memory cards and more.

Left: Always remember your vital accessories by keeping them in your camera bag.

Hot Tip

For lengthy shoots or holidays, it can't hurt to bring your battery charger with you, in order to charge one battery while using the other.

Right: Don't forget extra batteries for your camera.

Spare Batteries

There are few more frustrating things than running out of battery life at the wrong time, so be sure to pick up a spare for your camera. It's easy to find one for your camera model.

Hot Tip

Compact and smartphone photographers can get themselves into some crazy nooks and crannies with the GorillaPod tripod which comes complete with bendy legs that can be safely wrapped around all manner of objects.

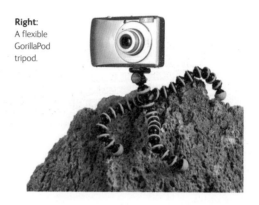

Right: A flexible GorillaPod tripod.

Below: A tripod will hold your camera in a precise position, resulting in a sharper picture.

Tripod

Keeping a steady hand can be one of the biggest challenges for a photographer. The slightest movement at the wrong time can result in out-of-focus snaps. You can line your shots up perfectly by screwing a tripod into your camera's tripod mount, located on the bottom of the device.

Memory Card Case

SD cards are pretty sturdy accessories, but there's no excuse for not looking after them. If you're switching memory cards quite often, then be sure to keep the spare cards in the plastic cases they arrived in.

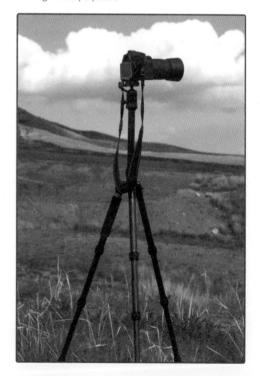

Left: You're less likely to lose your memory card if it's in its case.

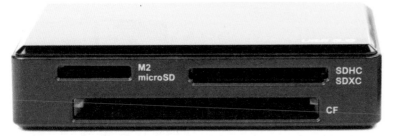

Above: It's handy to have a memory card reader suitable for all your memory cards.

Below: A medium grey card is a simple but vital tool.

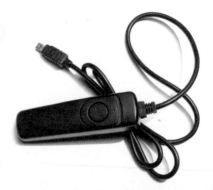

Right: When using your remote shutter, it is important to have a reliable tripod.

Memory Card Reader

Having your memory card reader present at all times allows you to easily transfer your snaps over to a computer wherever you roam.

Medium Grey Card

This cheap, simple accessory offers assistance as a reference colour when determining how to set your camera's exposure. Usually the other side is white, which allows you to select white balance perfectly.

Remote Shutter Release

Did you know you can take photos without touching your camera? A relatively inexpensive remote shutter-release trigger allows you to do just that.

Hot Tip

A remote shutter release is perfect for self-portraits or viewing the shot from another perspective.

Below: A light reflector will enhance any light source.

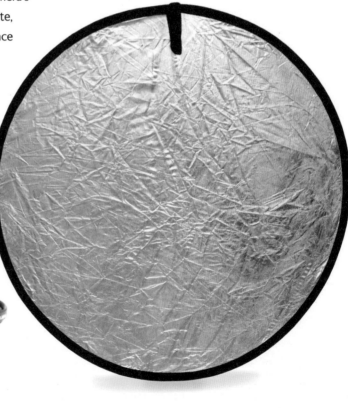

Left: Tinted lenses can make a dramatic difference to your photos.

MAINTENANCE

Digital cameras are very much like cars in terms of how you can best ensure their long-term survival. They work better with a little maintenance than with none, but tinkering is not advised.

AVOIDING DAMAGE

It is quite easy to break a digital camera, or at least render it useless, which is not quite the same thing. Dropping a camera repeatedly can lead to problems such as the shutter-release button working loose and even falling out, while sticky sliding lens caps are another common problem resulting from too much wear and tear. If your lens cap doesn't get out of the way of the front element of the lens, you cannot take pictures. This kind of thing often happens when cameras are incorrectly stored (in a tight trouser pocket, rather than on a strap or in its own bag), or used in adverse situations – on a windy day at the beach, for instance, or by children with sticky fingers. Sand and seawater in particular can be fatal to a digital camera.

Hot Tip

Beware: if sand gets into your lens, it will cause trouble sooner or later, and if seawater gets into your electronics, you may lose your camera completely.

Left: Use a specialist lens-cleaning kit.

REGULAR MAINTENANCE

If you get into a sensible cleaning routine at the end of a day's shoot, you can avoid these camera disasters. Cleaning includes checking that there is no sand or moisture in your camera bag, either. There is no point in cleaning the camera and then putting it into an even more hostile environment than you have used it in.

Cleaning Methods

Firstly, blow any extraneous matter off the camera before you start cleaning. Pay special attention to the lens barrel, and in the case of a DSLR, to the lens mount and mirror box. Always hold the camera so that you are blowing dust or dirt down and off rather than up and into the camera. For the lens and, specifically, the front element, first brush, then blow and only then, and with a special lens-cleaning cloth, sweep the lens radially (down) rather than in a circular motion. Give any hard matter a chance to fall off rather than being ground in.

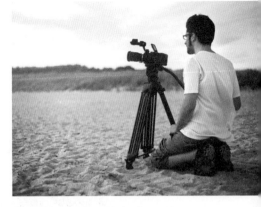

Above: Take care when at the beach, as sand and seawater are bad news for cameras.

Hot Tip

Using a blower brush means that you won't be blowing small amounts of saliva on to your camera.

CHECK IN ON YOUR CAMERA

Finally, always make sure that if your camera is stored somewhere other than on your person for a long period, that the batteries are kept outside. Batteries left too long can leak and corrode the contacts, and equally importantly, the on/off switch may get accidentally pressed and cause the camera to open in a confined space, damaging the lens irreparably.

Above: A blower brush and lubricant are useful accessories.

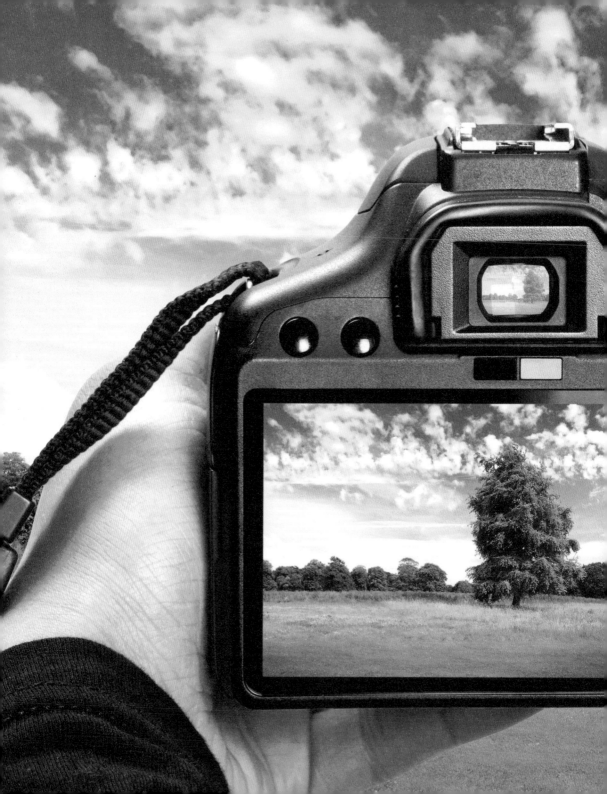

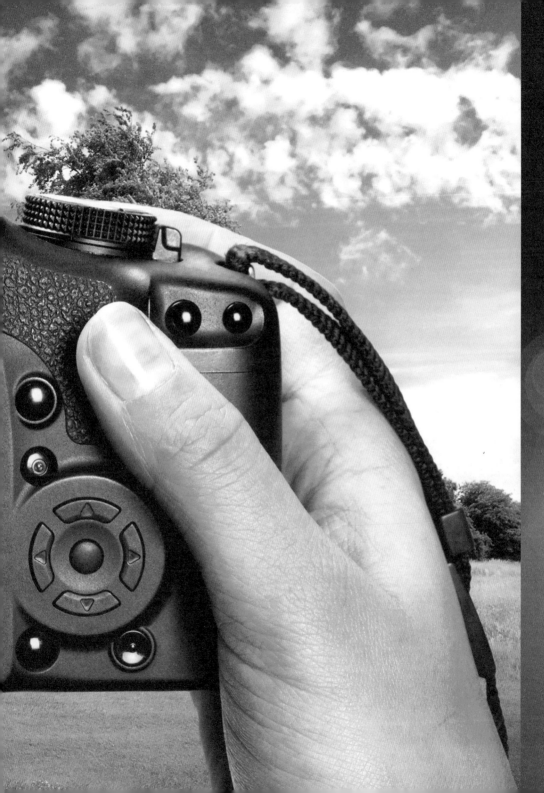

SHOOTING PROJECTS

LANDSCAPES

The rural landscape remains the greatest inspiration for hobbyist photographers. Luckily, good subjects are all around us, and few of us live far from an area of natural beauty – whether farmland, woodland, lakes, mountains, deserts or coasts.

BEST TIME TO SHOOT

Most landscape photographers aim to capture an idealized view, free from cars, people, pylons and other examples of modern life. This is one reason why they rise before dawn to be at their location when it is at its most undisturbed. This is also usually when the light is at its best, and good light is the most important ingredient in a successful landscape photograph.

Below: Natural features can sometimes be used to frame a photo.

WEATHER CONDITIONS

Landscapes can be photographed at any time of day though, as long as the light is good, and this does not necessarily mean sunshine. Fog, mist, rain and stormy skies are often more photogenic than bland summer sun. Obtaining the best light means studying it and waiting – minutes, hours, maybe even weeks or months – for that magic, fleeting moment.

FILLING THE FOREGROUND

Composition is crucial. A distant view from a hilltop may look great when you are there, but pictures in which all the points of interest are at the horizon rarely succeed. The best landscapes usually contain detail from foreground to horizon. Look for features such as gates, dry stone walls or flora to fill the void at the front of your picture. With a few exceptions, everything in the picture should be sharp, which means using a small aperture and focusing on a point in the middle distance to ensure crisp focus from foreground to horizon. In practice, this will probably mean using a tripod for stability at the slow shutter speeds.

CHOOSING THE LENS

Landscape photographers often favour wideangle lenses – more of the scene is in shot, the foreground has greater emphasis (for a better sense of perspective) and there is greater apparent depth of field. However, good landscape photographers are also able to see and home in on interesting details within a scene, either close up or in the distance, perhaps using a telephoto lens to isolate them from their surroundings.

TOP 5 TIPS

1. Wait for great light and, if possible, arrive at your destination very early.
2. Frame the subject to include points of interest from foreground to background.
3. Use a tripod and set the lens to a small aperture for maximum depth of field.
4. Use wide-angles for a more dramatic perspective, telephotos to isolate details.
5. Revisit locations at different times of year to record the changes.

SUNRISE & SUNSET

Despite the cliché status of sunrises and sunsets, we never seem to get tired of them. They are nature at its most majestic, most magnificent. Taking good photographs of them though, is not always so easy.

TOO MUCH GOING ON?

The reason behind our frequent lack of success is partly because the automatic exposure and white balance functions of digital cameras conspire to eliminate just those qualities that make these events so appealing in the first place, and partly because we are often so wrapped up in how lovely the sky looks that we fail to pay sufficient attention to what is going on in the foreground.

THE IDEAL FOREGROUND

Clean, simple, uncluttered foregrounds work best. The most successful examples are those where the foreground makes an interesting and instantly recognizable silhouette. Bare winter trees, for example, or people can make very interesting foreground silhouettes. One of the best types of foreground is water: lakes, rivers, the sea – even a big puddle – because it reflects the beauty of the sky.

Left: Silhouetted buildings look very dramatic.

CHOOSING THE SUBJECT

Sunrise and sunset prop up either end of the day like bookends. It does not matter which you shoot – both can produce spectacular results. Sunrise has the advantage of being quieter, with fewer people and cars to spoil things, but you have to get up very early to catch it.

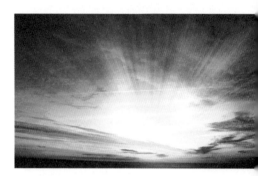

TECHNICAL ADVICE

Whichever you choose – sunrise or sunset – you should be at your selected spot well in advance. Use a tripod for stability. Your auto white balance will try to neutralize the colour and remove the orange hue, so turn off the auto and set it to daylight for maximum saturation – or for more control, shoot RAW files and sort out the colour balance later.

You may find that autoexposure produces unsatisfactory results too, as it tries to lighten your sky. Either take a manual reading from a bright part of the sky (but not the sun), or use exposure compensation of minus 1–2 stops. Once the sky reaches maximum saturation, keep shooting until well after it has gone, especially at sunset when you can get some wonderful effects from the afterglow.

Location, Location, Location

Finally, bear in mind that the further north you go, the longer you have to shoot your sunset. The nearer the equator you are, the faster the sun goes down.

TOP 5 TIPS

1. Choose an interesting foreground, such as water, or a recognizable silhouette.
2. Get there early, and use a tripod.
3. Set the white balance to daylight – not auto.
4. Meter from the sky and check your exposures. Underexposure increases saturation.
5. Take lots of pictures, and keep shooting until well after the sun has risen or set.

SPORT & ACTION

We've all got pictures of half a car or part of a person just leaving the frame, as we tried to photograph them but were a split second too late pressing the shutter.

BLINK AND IT'S GONE

It doesn't help that digital cameras in particular have a reputation for being slow to react to fast-moving situations. While this issue has now been largely solved on the newer cameras, even the swiftest cameras will let you down with fast action unless you adopt a few useful techniques.

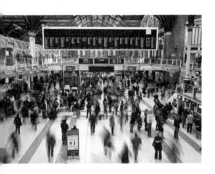

SHOOTING OPTIONS AND TECHNICAL IMPLICATIONS

There are two ways to shoot action: freeze the motion, or introduce deliberate blur to convey the sense of speed.

Freeze Frame

For family action shots, the former is generally preferred so you will need to select a fairly fast shutter speed, via shutter priority mode, manual or sports mode. If you have selected a speed too fast for the prevailing conditions, your camera should warn you, but review your efforts on the LCD to be sure.

Deliberate Blur

To introduce an element of deliberate blur, you will need a slower speed (1/30 sec or below, depending on the type of action) and either allow the subject to blur itself as it moves, or follow the subject's motion with the camera to create a streaked background.

Whichever approach you prefer, you still need the camera to fire at the right moment, and there are ways to maximize its responsiveness. Turn off the autofocus and pre-focus on a spot where you know the action will take place. If you can't turn it off, use the focus lock. Failing all that, at least set the camera to continuous AF mode, which lets you take a picture without having to lock the focus first. Set the drive to continuous too, so that the camera will keep shooting as long as your finger is on the shutter.

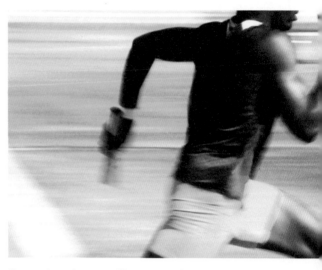

Above: A slower shutter speed blurs movement for an artistic effect.

POSITIONING

Pressing the shutter as you pan will minimize the risk of the subject leaving the frame before the shutter goes off. Alternatively, practise pressing the shutter just before the subject comes into the frame. If you position yourself so the motion is coming towards you rather than across your path, the illusion of speed is minimized, improving your chances of getting it both correctly framed and in focus. This technique is especially useful for motorsport photography. Remember that objects moving across the frame need a much faster shutter speed to freeze them than objects coming towards you. Some cameras now have impressive burst modes that allow you to capture multiple frames a second.

TOP 5 TIPS

1. Set a fast shutter speed to freeze action.
2. Set a slower speed to add creative blur to convey movement.
3. Set the camera to manual focus and pre-focus on where the action will occur.
4. Select continuous drive mode and, if no manual focus, continuous AF.
5. Position yourself so that fast-moving subjects are coming towards you.

POSED PORTRAITS

The difference between candid and posed portraits is that with one, the photographer is reacting to situations, while with the other, he or she has to create them. Creating a natural-looking portrait, especially with a model lacking in confidence, is no easy task.

CHOOSE YOUR SETTING

Posed portraits can be done outside or indoors, in a studio or a real room (home, office, etc.). Natural settings may make the model feel more at ease, whereas studios can seem intimidating. Whatever the setting, three factors are crucial: lighting, pose and expression.

Above: Capturing a highlight in the eyes really brings the photograph to life.

Lighting

For most portraits, the light ideally should be diffused but directional.

- **Inside:** Placing your model near a window on a cloudy day is ideal. On a sunny day, net curtains can help diffuse any harsh lighting. If the light is striking one side of the face, you may wish to use a white reflector to bounce light back onto the dark side of the face to reduce the shadows. Some photographers seek to replicate the effects of soft window light using studio lighting, by fitting a white umbrella or softbox to create the same diffused look.

- **Outside:** Outdoors, direct sunshine produces harsh shadows and makes people squint, so look for shaded spots such as under a tree, against a north-facing wall, or indeed anywhere if it is cloudy. Use reflectors if necessary to direct the light, and perhaps create a highlight in the eyes (which is hugely desirable, because it makes them sparkle).

Alternatively, on sunny days place the model in front of the sun to create an attractive halo around the hair. You may need fill flash or a reflector to light the face.

Choosing a Pose

Find a natural pose that suits your model. Some people are comfortable standing, others look more comfortable sitting. Take care with hand placement, as some people become self-conscious about them when being photographed. Give them something to do with their hands, such as holding a book, or resting their chin gently on a palm. Legs, too, can be problematic. If they are stretched out towards the camera, feet can appear oversized. If in doubt, crop them out of shot.

Expression

Finally, facial expression is vital, though this doesn't necessarily mean smiling. A natural smile is great, but a forced one is worse than no smile at all. Direct conversation to contrive good natural expressions, whether these be thoughtful, wistful or sexy. Be ready for fleeting expressions. Take lots of pictures to increase the chances of getting a good shot.

COMPOSITION

If photographing more than one person, place them close together with their heads at different heights and try to create an interesting compositional shape. Turning their bodies to face in towards each other creates a harmonious appearance.

Finally, never ask anyone to say 'Cheese'. Ever.

TOP 5 TIPS

1. Natural sittings, indoors or out, produce more natural portraits.
2. Indoors, use natural window light, with reflectors to light the shadows.
3. Outside, shoot in shade or with the sun behind the subject.
4. Pose the subject in a position that looks natural and feels comfortable.
5. Try to elicit natural expressions through direction. Don't ask for smiles on demand.

CHILDREN

Making a record of your children's lives as they are growing up is something that both you and they will treasure when you are all much older.

PRECIOUS MOMENTS

With digital cameras there is no excuse for not being trigger happy, because it doesn't cost anything and you can delete the failures later. But don't just record the key events – the big family get-togethers – nor make them grimace into the camera with fake smiles. Instead, make an effort to capture those smaller, more intimate moments when they are playing in the garden or riding their bikes, or they are indoors doing arts and crafts. These are the moments you will remember and treasure. You can set up fun activities for the children with picture-taking in mind. After you've taken the snaps, be sure to back them up at the earliest possible opportunity. They are truly irreplaceable.

FACIAL EXPRESSION

In general, unposed shots with natural expressions that capture the children's personalities are far superior, and will bring back much more poignant memories than posed shots. But there is nothing wrong with getting them to look into the camera if you can get genuine expressions – smiles or otherwise – out of them. Even the odd tantrum or sulking shot will raise a smile when viewed in later years.

TECHNICAL ADVICE

Your best strategy when photographing children is to be always ready and react quickly to events. Close-range shooting with a wideangle lens will provide impact and a sense of intimacy. Presetting a camera to manual focus, a mid-range aperture and focal point of about

3 m (10 ft) will cut down the shutter lag and make picture-taking almost instantaneous. In low light, set a high ISO rather than flash, which will remind them of your presence.

POSITIONING

When photographing children at close range, it is generally best to get down to their level. This creates a more intimate image and gives the viewer a sense of entering the child's world, rather than being an outsider looking at the tops of their heads. That said, sometimes a shot looking directly down, with children looking up, can add humour or a sense of pathos to a situation.

- **Be an observer**: With DSLR cameras, or models with good zooms, an alternative strategy is to step well back with a long lens so they forget you're there, and observe, with your finger hovering on the shutter. Don't just go for full-length shots showing what they are doing – zoom right in and get some frame-filling head shots too.

Above: Be ready to capture spontaneous moments.

TOP 5 TIPS

1. Take lots of pictures, all the time, and not just at special occasions.
2. Go for natural expressions, not forced smiles. Get some sad and grumpy shots too.
3. Pre-focus or set manual focus to cut the shutter delay and be always ready.
4. At close range stoop down to their level rather than looking down at them.
5. Try standing some distance away and shooting candids with a telephoto lens.

WEDDINGS

Few things are as intimidating to a photographer as being asked to photograph a wedding. The responsibility of capturing what is, to your clients, the most important day of their lives, can be overwhelming. Careful planning and organization will make it run smoothly.

Above: Try to keep the posed shots as natural as possible.

MIX IT UP

Firstly, talk to the couple to ascertain their needs. Find out the location, the number of guests, timings and the logistics of the day. Many young couples now prefer an informal fly-on-the-wall approach to the traditional posed shots, but a good wedding shoot should be a mix of both styles. Older guests will expect a few group shots, and these are the only opportunities to make sure that you have a decent shot of everyone who was there, because it is easy to miss people when using the reportage approach. It is also advisable to have a few posed shots of the couple, but don't keep guests hanging around while you take them – keep it brief. Be loud, clear and decisive in your instructions so people know when they are needed.

PLAN AHEAD

Scout the venues beforehand to seek out potential locations for the posed shots, either outside the wedding venue or at the reception. Go for places out of direct sun and with plain, but not ugly backgrounds. Make a list of the shots you need

to get – exchanging the rings, cutting the cake, etc. – and refer to it on the day. Find out if there are any restrictions on taking pictures during the ceremony. If you are allowed to shoot, be discreet, and don't use flash. Natural light looks better and is less obtrusive.

EQUIPMENT

Check your equipment before the day and make sure you have a spare camera and batteries. You can never have too many spare memory cards or batteries. Check all your settings before shooting, and refer to the

Above: Look for interesting angles for the standard shots.

histogram to ensure the exposures are good. Be careful with white dresses in sunshine, which can burn out and lose detail, especially when the groom is wearing a dark suit. Afterwards, back up the pictures immediately, for safety.

Finally, if you are not the official photographer and are just taking some behind-the-scenes shots, try not to get in the way of the professional.

TOP 5 TIPS

1. Talk to the couple beforehand to discuss their needs.
2. Scout the venues beforehand to look for suitable locations for posed shots.
3. Take a mix of posed groups and single shots plus natural candids.
4. Work quickly and decisively. Don't delay people for too long.
5. Take a spare camera. Check settings and results regularly. Back up immediately.

TRAVEL

Few genres are as rich in subject matter as other people's countries. There is something about visiting foreign, unfamiliar places that fires up the creative juices and lets us see potential pictures in things that locals may have long since stopped noticing.

NEW SPIN ON OLD FAVOURITES

When we think of travel photography we usually picture images of the Eiffel Tower or the Taj Mahal. But, while it is unthinkable that we should not photograph these familiar wonders when we visit them, try to see them with fresh eyes, and seek out viewpoints and treatments that will put a refreshing new spin on them.

Above: The most ordinary subjects can make fascinating, unusual images.

TRY SOMETHING NEW

Most importantly, don't limit yourself to pictures of grand views and world icons. Travel photography is all about telling the story of the place – to convey a sense of the essence of the culture for those who have not been there.

○ **Small details:** Try to capture little vignettes that encapsulate the spirit of the place you are visiting – perhaps unfamiliar foods displayed on a market stall, or a sign over a shop door. Look for the small details as well as the wide shots. Use the full range of your lenses to capture the wide spectrum of subjects.

○ **Local characters**: A country is its people as well as its geographical features. Take some portraits of interesting locals. Nice, tightly cropped headshots of colourful characters are always effective, but pay them the respect of asking them first, even if only in a non-verbal way – unless of course you are shooting candids and are able to work unobserved.

EQUIPMENT TIPS

There are a few practical considerations too. Choose a gadget bag that you can carry on your flight as hand luggage. Never check your cameras into the hold. Pack plenty of spare media cards and spare batteries. Take a tripod, even if only a pocket one, so that you can take sunsets and night shots of spectacular views. If you have a lot of kit, pack a smaller day bag so that you can leave some of the heavy stuff at your hotel. Do not show off your gear but keep it discreetly in your bag or under a jacket when not in use.

Above: Look for unusual architecture.

TOP 5 TIPS

1. Pack spare cards and batteries and take your gear as hand luggage.
2. Try to find new and original approaches to familiar icons.
3. Work to tell a story of the place in pictures, and convey its spirit and culture.
4. Look for small details as well as general views.
5. Photograph the people, if they don't mind, but desist if they object.

PETS

Cats and dogs make great subjects for pictures. Cats have their famous aloofness, dogs their intrinsic comedic value – both make natural subjects.

GETTING THE RIGHT SHOT

Animals photograph well when captured head-on, looking directly into the camera. Zoom in closely to fill the frame for maximum impact, preferably at a wide aperture to throw the background out of focus. Don't be afraid to make a fool of yourself to attract the animal's attention.

EXPOSURE ISSUES

Exposure can be a problem with some animals, especially those with dark

Right: An action shot is tricky to achieve, but worth the effort.

Above: Dogs are fantastic subjects to photograph.

or light fur. Dark fur can easily underexpose because it absorbs so much light. White fur in sunshine can burn out and lose all detail. Try overexposing by a stop with dark animals and underexposing with brightly lit white ones, but check the histogram on the camera to make sure.

TOP 5 TIPS

1. Always keep a camera ready for any great pet moments at home. Be patient.
2. For portraits, fill the frame. Attract their attention with a toy or by making noises.
3. Try using a ball, toy or food treat to catch their attention and direct their gaze.
4. Visit a farm park to get good close-ups or environmental shots of farm animals.
5. Increase the metered exposure for dark-furred animals, decrease it for white fur.

WILDLIFE

In addition to the obvious photographic skills, successful wildlife photographers need an encyclopedic knowledge of the subject, and lots of patience.

KNOW YOUR SUBJECT

Firstly, rather than wandering aimlessly in the woods, snapping anything that comes along, choose a subject that you wish to photograph and seek it out. It helps if it lives in an area local to you, because you can spend more time on your quest and get to know your subject better. Next, read up on the behavioural habits of your subject: where it lives, what it eats, when it comes out to feed, and so forth.

Above: A wildlife safari will ensure you get some great photographs.

THE APPROACH OPTIONS

Most wildlife is shy and there are two approaches to getting close to it: stalking or finding a spot and lying in wait. Learning to quietly creep up on your subject without it noticing is a skill that must be learned through practice. Equally, many wildlife photographers spend not just hours but days sitting silently in a hide – a small camouflaged den made of wood, canvas or other material in which the photographer waits, with small holes for the lens to protrude from.

○ **Common or Garden:** If all this sounds like too much commitment, there are easier ways. Stick with common, accessible subjects such as squirrels or birds. You can attract wildlife to your garden by planting the right shrubs or putting out appropriate food.

○ **Go on Safari:** If your taste is for more exotic wildlife, such as big cats, then you have two options: go on a wildlife safari (there are some tailored especially for photographers) or visit the zoo or safari park. You can get surprisingly good shots in these places, if you compose carefully to avoid including cages, cars and crowds in the shot.

EQUIPMENT NEEDS

Whichever approach you take, there are certain equipment needs common to almost all wildlife photography, the most important of which is a long telephoto lens. Some photographers prefer zooms, for their versatility, others favour fixed focal-length lenses for their faster maximum apertures. Either way, whether you are shooting in your garden, at the zoo or on the Serengeti, you are likely to need lenses of at least 200 mm (equivalent) and maybe up to 600 mm. Shorter lenses can be used for environmental shots, where the animal is a small part of a wider view showing the setting. These shots provide context, but you will still want the close-ups. A sturdy tripod is also essential when using big lenses.

Above: A zoom or telephoto lens is well worth investing in.

TOP 5 TIPS

1. Study your subject. Find out where it lives, what it eats, etc.
2. Stick with local subjects to start with – they are more accessible.
3. Try attracting wildlife to your garden, and shooting from the house.
4. Practise in zoos and wildlife parks.
5. Crop tightly to exclude giveaway details. Make sure you have at least one decent zoom/telephoto lens in the 200–400 mm range.

NATURE

Although wildlife and rural landscapes could be considered nature subjects, the term usually refers to the photography of plants, flowers and trees, and the butterflies, bees and small creatures that live off them.

TAKE NOTHING BUT PHOTOGRAPHS

Nature photography is generally conducted in situ, and with an ethic that involves leaving your subjects the way you found them – undisturbed and unmolested. In some situations, subjects can be removed with a clear conscience and taken to a studio environment (fallen leaves, for example).

OPTIMUM LIGHTING

The ideal light for most close-range nature photography is soft, overcast light, which creates virtually shadowless illumination. Bright sun can cast harsh and distracting shadows on the subject, which makes it difficult to see fine detail and reduces colour saturation. In some situations, a strong sidelight or backlight can add an element of atmosphere, creating (in the case of backlighting, for example) an attractive halo around the subject.

Left: Insect close-ups can make stunning photographs.

GETTING A STABLE SHOT

When photographing subjects such as flowers close up, use a tripod for stability and make sure the background is blurred so as not to cause a distraction. You may find it easier to get further back and zoom in using a longer telephoto lens to achieve this. If you are at or near ground level, a small beanbag may be easier to use than a tripod.

MANIPULATING THE LIGHT

To enhance the light you can use creased foil or white paper as small reflectors. Occasionally, fill-in flash can be useful, in small doses. Commercially made reflectors fold up very small but can open up to provide useful fill light as well as acting as a shield to stop the wind blowing your subject around – and therefore in and out of focus. Another trick is to use a thin piece of stiff wire behind the stem (out of camera shot) as a splint, to help keep the plant steady.

Above: Quick responses are required when photographing natural subjects.

TOP 5 TIPS	
1.	Soft, overcast light is generally the most flattering.
2.	Low sidelight or backlight can help to create a sense of atmosphere.
3.	Use a tripod or beanbag for stability.
4.	Set a wide aperture – perhaps combined with a long lens – to blur the background.
5.	Use reflectors (bought or home-made) to modify the light and create a windbreak.

CLOSE-UPS

There is a whole world of beauty and wonder, pattern, shape and colour just waiting to be photographed, if you can get close enough.

MACRO MODE

Luckily, almost all digital cameras come equipped with a macro mode that lets you get within a finger's length of your subject, and often even closer, though with DSLRs you may need to use a macro lens or attach a supplementary close-up accessory to your existing lens.

Above: Unusual views of everyday subjects work well.

INDOORS OR OUTDOORS?

There are two ways to choose a close-up subject. You can go out into the world and home in on leaves and plants, vehicle details, etc., or you can create your own subjects at home – slice a kiwi fruit in half, or raid the children's toy cupboard. By careful use of composition, it is easy to create images that show an unexpected, perhaps even unrecognizable view of a normally familiar subject.

THE TECHNICAL ASPECT

There are, however, some technical challenges that must be overcome. Firstly, as you get closer to your subject, the depth of field diminishes, until at very close range, it is reduced to a narrow plane

of just a few millimetres, even at the smallest aperture. This means that accurate focusing becomes critical. A tripod is essential for macro work, because a tiny movement of the camera can make the difference between a picture being in or out of focus. For small-scale macro work a tabletop tripod is sufficient, though for nature close-ups in the field you will need a full-size one.

FOCAL POINTS

This shallow depth also means that you must exercise care in your composition, manoeuvring either yourself or your subject so that the important plane of interest aligns with the plane of focus. Alternatively, you can use this rapid loss of sharpness to your compositional advantage, using it to draw the eye to a sharp focal point in a sea of blur.

Above: You may need a tripod when shooting close-ups.

SELECTING THE LIGHTING

Lighting can be challenging at close range. Outside close-ups should be less of a problem – perhaps a small reflector to give daylight a helping hand – but indoors, try experimenting with window light and artificial light such as table lamps. Does your subject look best with a soft, diffused light or a hard, directional one? As always, shoot many variations and check your results on the LCD screen as you go.

TOP 5 TIPS

1. Look for subjects that are interesting or unusual at close range.
2. Set your camera to the macro mode, if you have one. (Almost all compacts do.)
3. Use a tripod.
4. Fire the shutter using the self-timer to minimize vibration. You'll get minimal depth of field, even at small apertures. Make the most of this.
5. Take care over your lighting. Review your efforts on the LCD to see how it looks.

STILL LIFE

A still life is a pictorial representation of one or more inanimate objects, arranged and lit in a visually pleasing way. It has been popular with painters for centuries and it is no less so with photographers.

Above: The most ordinary subjects can become works of art.

TYPES OF STILL LIFE

There are two kinds of still life: the type you find and the type you create.

Found

Found still life subjects are often natural objects such as pebbles on a beach or fallen leaves in autumn. This also includes accidental art created by weeds growing out of a rusty bucket, or bottles on a windowsill. Still-life subjects are all around us if only we look for them, though many need a little helping hand to maximize their potential – perhaps moving one of the elements slightly, or removing something distracting from the background.

Created

Then there is the still life you create – on a table in the kitchen, or a studio light table. You bring all the elements together, arrange them, light them and photograph them. Any object is suitable, though if you are photographing a collection of objects, it helps if there is a common theme. A still life of an apple, a razor and a toy train, for example, would not necessarily make much sense.

LIGHTING IS KEY

Both types of still life need common attributes. The most important of these is good, sympathetic lighting. Whether it be hard or soft, warm or cool, a still life will rarely inspire gasps of admiration if it is not exquisitely lit, and still-life photographers spend hours adjusting the light.

- **Outside:** If you are outside, you can't change the light, but you can modify it with reflectors, diffusers or a blip of fill flash, or you can return another day when the light has changed.

Above: Well-lit food photography can make a stunning still-life.

- **Indoors:** Indoors, you are creating the light. Use the natural light from a window, or artificial lights, such as table lamps or professional studio lighting. Either way, use white or metallic reflectors and black card to direct and channel the light to where you want it.

SETTING THE SCENE

With an indoor still life, pay special attention to the choice of background too. Plain white is fine, but you can use textured art paper, foil, fabric, wood, sheet metal, ceramic tiles, piles of leaves or whatever you think appropriate.

TOP 5 TIPS

1. Look for natural still-life subjects around you.
2. Create your own still-life on a table at home.
3. With collections of objects, make sure they have a common theme.
4. With a created still life, choose a sympathetic and attractive background.
5. Lighting is crucial. Spend time getting it right.

ARCHITECTURE

Architecture is photogenic. From the pyramids and Stonehenge to the Guggenheim Museum and the Empire State Building, we love to photograph buildings, both ancient and modern.

PICKING YOUR MOMENT

There are some difficulties though. We may not be able to stand where we want, because other buildings are in our way. The light may be coming from the wrong angle, or there may be too many people.

The first thing to remember about buildings is that you cannot move them, so if the light is not where you want it, return at another time. Observe which façade the light strikes at a given time of day (a compass is useful here) and if you want to shoot the front, but it is west-facing, you know that you will need to return in the afternoon.

AVOIDING DISTORTION

Having arrived at the optimum time, the next task is to locate a viewpoint that minimizes distortion of the building. In an ideal world, you would be positioned in the centre of the façade, some distance back, with a telephoto lens. Assuming you can find a central spot, you will probably be quite close and will have to use a wide-angle and tilt the camera upwards to capture the top. This results in 'keystoning', or converging verticals, where the sides lean in and the building appears to be toppling over backwards.

- **Avoiding Keystoning**: There are two solutions: try to find a higher viewpoint – such as a balcony opposite, at half the height of the building you are photographing – or get it as straight as you can and correct the perspective later on your computer.

ZOOMING IN

With many buildings, there are lots of opportunities for close-up detail shots: gargoyles and ornate stonework on old buildings, radical angles and glass reflections on new ones. Use a telephoto lens to isolate them if necessary.

CITYSCAPES

Most cities also offer a high vantage point from where you can get good shots of the entire skyline. The best time is often early or late in the day, when the sun is lower in the sky and less harsh. Evenings are particularly good because the buildings are often lit up, which adds an extra visual dimension. Go for wide-angle views or pick out details with a telephoto.

Above: Even fake skylines make a striking photograph.

TOP 5 TIPS

1. Note which way buildings face and shoot at the right time of day for the best light.
2. Shoot from a central position to minimize distortion.
3. Avoid tilting the camera. With tall buildings, try to find a higher viewpoint so you can keep the camera level.
4. Look for interesting details that you can zoom in on. Shoot city skylines from a high vantage point.
5. Choose sunset or night for drama.

INTERIORS

There are so many beautiful architectural interiors in the world – in cathedrals, theatres, stately homes and other buildings – that you could photograph nothing else and never run out of subjects. But many photographers are intimidated by them, thinking that they require a great deal of specialized equipment.

EQUIPMENT ESSENTIALS

There are some basic equipment needs that will make life easier, but for many locations, all you need is a tripod. There are, for example, many stunning modern interiors, often with vast expanses of glass letting in a great deal of natural light.

- **Tripod**: A tripod lets the photographer ensure that the camera is completely level, and allows the use of small apertures for maximum depth of field, but is not essential.

- **Wide-angle Lens**: Most interior photography, however, is of much older buildings, where light is low and a tripod is necessary – as is a decent wide-angle lens, although if it is too wide, you will struggle with distortion.

For general views of cavernous interiors such as cathedrals, set your camera up on the tripod at one end and make sure it is pointing straight ahead. Tilt it upwards and sides will appear to lean inwards – though in some cases, this kind of deliberate, exaggerated distortion can work well, especially to emphasize height.

CHALLENGING LIGHT

In low light, it may be tempting to increase the ISO rating, but this will reduce image quality, so do this only as a last resort (e.g. you cannot use a tripod, or exposure times extended over a

minute). Many interiors feature a mixture of light sources – perhaps tungsten lamps, with daylight coming through the windows.

Above: Adjust white balance settings to accommodate different lighting sources.

○ **White-balance Settings:** Since it is impossible to get both right, experiment with your white-balance settings.

○ **RAW Mode:** If you can, shoot in RAW mode, as this will provide more colour correction latitude later.

○ **Extra Flash:** If you have additional lighting with you, some interiors benefit from extra flash or tungsten light to fill in badly lit shadow areas. These will have to be used off-camera, and directed specifically into the areas that need it. A slave flash, which can be triggered remotely via a small blip from your on-camera flash, is perhaps the easiest to operate.

INTERIOR FEATURES

In your haste to get the wide shots, don't forget to look out for interesting details to isolate: perhaps an ornate banister, a spectacular chandelier, a painted ceiling or a stained-glass window.

TOP 5 TIPS

1. Take a tripod, to keep the camera level and enable small apertures.
2. Use a wide-angle lens, between 24 mm and 35 mm (equivalent).
3. To avoid distortion, keep the camera level and avoid ultra wideangles.
4. Fit a longer lens to isolate interesting details. Look for unusual angles.
5. Keep the ISO as low as possible. Use off-camera flash if necessary to fill shadows.

NIGHT & LOW LIGHT

Night-time can often provide some of the best photographic opportunities, especially in urban areas. The most obvious subject is architecture. Churches and grand civic buildings are often beautifully lit and can look better at night.

IDEAL TIME TO SHOOT

Don't wait until it is dark – dusk is the best time to shoot, when there is still enough ambient light in the sky to fill in the unlit parts of the building, and reduce the contrast between those parts and the areas bathed in the spotlights. A navy blue dusk sky also helps to highlight the outline of the building.

Technical Details

Set the camera to RAW mode (if possible – if not, use daylight white balance in JPEG mode) and the lowest ISO you can, put the camera on a tripod, stop down to f/8 of f/11 and see what exposure time the meter gives you. It may be anything from 10 seconds to more than a minute. Try to avoid exposures much longer than this, as it will increase the noise levels in the image. Wait for a gap in traffic before shooting, though fast-moving people will probably not record on the image during long exposures.

Left: Neon signs come alive in low light.

GREAT NIGHT-TIME SUBJECTS

There are plenty of night-time shots that can produce spectacular results:

Above: Cityscapes offer lots of inspiration for night pictures.

- **Traffic Trails**: One of the most fun things you can do at night is to shoot traffic trails, where you deliberately focus on a busy road and allow car head and tail lamps to record as streaks during an exposure anywhere between 10 and 30 seconds. Try to include the backs of cars as well as the fronts, so that you capture both red and white streaks.

- **Funfairs**: Funfairs are another location where moving lights make great pictures. Illuminated rides such as Ferris wheels can produce wonderful streaks of blurred colour during long exposures.

- **Fireworks**: You can also photograph fireworks displays. With a standard lens or slight wide-angle fitted, set the camera up on a tripod, pointing at the sky. When the fireworks go up, open the shutter to record the burst. If you have a 'B', setting keep the shutter open, replace the lens cap, then open it again for the next burst, building up several bursts on the same exposure. Failing that, use the longest exposure time available, or take several shots and combine them into one image later.

TOP 5 TIPS

1. Take a tripod.
2. Use the lowest ISO you can, select RAW mode or daylight white balance in JPEG.
3. Shoot at dusk, when there is still some colour in the sky, not when it is pitch black.
4. Stop down to f/8 of f/11 and keep exposure times between 10–60 seconds if possible.
5. Try shooting traffic trails, fairgrounds and fireworks, for great motion effects.

FURTHER READING

Adair King, Julie, *Digital Photography for Dummies*, John Wiley & Sons, 2012

Ang, Tom, *Digital Photography: An Introduction*, Dorling Kindersley, 2014

Ang, Tom, *Digital Photography Masterclass*, Dorling Kindersley, 2013

Ang, Tom, *Digital Photography Month by Month*, Dorling Kinderlsey, 2012

Bowker, Daniela, *Social Photography: Make All Your Smartphone Photos One in a Billion*, Ilex, 2014

Busch, David, *Digital SLR Cameras and Photography for Dummies*, Hungry Minds Inc., 2014

Carroll, Henry, *Read This If You Want to Take Great Photographs*, Laurence King, 2014

Evening, Martin, *Adobe Photoshop CC for Photographers*, Focal Press, 2013

Farrell, Ian, *Complete Guide to Digital Photography*, Quercus, 2014

Freeman, Michael, *The Digital SLR Handbook*, Ilex, 2011

Garvey-Williams, Richard, *Mastering Composition*, Ammonite, 2014

Hess, Alan, *Night and Low-Light Photography Photo Workshop*, John Wiley & Sons, 2012

Kelby, Scott, *The Digital Photography Book*, Peachpit Press, 2014

Lonely Planet, *Lonely Planet's Best Ever Photography Tips*, Lonely Planet, 2013

Walker, Liz, *52 Weekend Digital Photo Projects*, Carlton Books Ltd., 2013

Weston, Chris, *Mastering Your Digital SLR: How to Get the Most Out of Your Digital Camera*, RotoVision, 2009

Weston, Chris, *Digital Wildlife Photography*, Photographers' Institute Press, 2008

Wyatt, Williams, *Photography: Digital SRL Crash Course!*, CreateSpace Independent Publishing Platform, 2014

Yabsley, Lorna, *The Busy Girl's Guide to Digital Photography*, David & Charles, 2013

WEBSITES

www.amateurphotographer.co.uk
The UK's longest-running photographic magazine has a strong online presence with regularly updated news pages, forums and reader photos.

www.ephotozine.com
While a good source for the latest news, undoubtedly the highlights of ephotozine are the reader galleries and portfolios, which have the feel of a real online community.

www.flickr.com
A photo-sharing and hosting service allowing you to store and share photos with friends and family, or the world.

500px.com
A photo community for discovering, sharing, buying and selling high-quality photography.

www.imaging-resource.com
From news, camera reviews and photo galleries, to forums and useful lessons on photographic technique, Imaging Resource contains a little bit of everything.

instagram.com
Instagram is one of the world's most active and popular photo and video sharing social networking sites with more than 150 million active users.

www.jessops.com
High-street photography retailer Jessops has a user-friendly website, offering prints at a range of different sizes and gift formats at mid-range prices. By registering you can store your photographs in an online album.

www.luminous-landscape.com
With emphasis on the genre of landscape photography, Luminous Landscape has some great essays along with reviews, news and tutorials.

www.pbase.com
One of the foremost sites for photo-sharing on the internet. For a yearly fee you can obtain 300 MB of storage and create your own gallery.

www.photobox.com
As well as having a superb online gallery, Photobox frequently wins awards for its photo printing service. Prices are reasonable and you can print on to a wide range of paper sizes as well as an extensive selection of gift products.

www.pocket-lint.com
News and reviews on the latest 'gadgets, gear and gizmos', including software, phones and digital cameras, presented in a user-friendly format.

www.steves-digicams.com
This US-based site contains extremely detailed reviews of masses of digital cameras (past and present), printers and accessories.

www.whatdigitalcamera.com
The website for one of Britain's best-selling digital photography magazines, containing regularly updated news, test pictures from the latest issue, downloadable tutorials and reader photographs.

INDEX